IMAGES
of America

NEW BRITAIN'S
ARMENIAN COMMUNITY

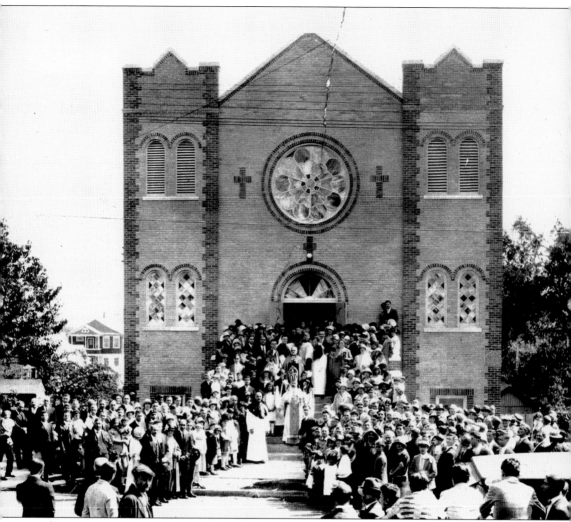

The entire New Britain Armenian community gathered for the consecration of St. Stephen's Armenian Apostolic Church in May 1926. A committee was elected at a meeting in 1900 to plan for the building of this church. It is interesting to note the number of men in this photograph as compared to the cover, which was taken at Easter in 1933. Between those years, survivors began coming to New Britain and creating families.

On the cover: Photographed here is St. Stephen's Armenian Apostolic Church. This photograph was taken on Easter 1933. (Courtesy of St. Stephen's Armenian Apostolic Church.)

IMAGES
of America

NEW BRITAIN'S
ARMENIAN COMMUNITY

Jennie Garabedian

ARCADIA
PUBLISHING

Published by Arcadia Publishing
Charleston SC, Chicago IL, Portsmouth NH, San Francisco CA

Printed in the United States of America

Library of Congress Catalog Card Number: 2008922003

For all general information contact Arcadia Publishing at:
Telephone 843-853-2070
Fax 843-853-0044
E-mail sales@arcadiapublishing.com
For customer service and orders:
Toll-Free 1-888-313-2665

Visit us on the Internet at www.arcadiapublishing.com

*This book is dedicated to my father, Toros Garabedian,
who was a citizen living in the United States, whose dedication and
loyalty to his family brought them here after the genocide. Also, to my
mother, Dirouhi Der Torossian Garabedian, whose strength and courage
kept her family together during the long and tragic 15 years
of separation from her husband.*

CONTENTS

ACKNOWLEDGMENTS

New Britain's Armenian community has been overwhelmingly generous in sharing their memories and photographs. Some of the pictures are very precious, because so much of what they had was lost in the Armenian Genocide. These are a few mementos of their families. Most have no pictures of their parents and grandparents or how they lived while in the Ottoman Empire because everything was destroyed, including even the graves of ancestors in the villages.

I am especially grateful to Yevpime Musluyan, who guided me in my trips to my parents' homeland. This helped to give roots to my life. A great deal of research was done at the New Britain Public Library History Room by Charles T. Avedisian. He provided the basis of information needed for this book.

It is a difficult task to select individuals by name to thank for their help and generosity. Each person in the community has been so wonderful in sharing stories and pictures. Special appreciation goes to the members of the Armenian Church of the Holy Resurrection and St. Stephen's Armenian Apostolic Church. Also the Armenian American members of the First Congregational Church have been helpful in providing photographs of the congregation of that church. I am truly sorry some of the images could not be used due to the limitations of space.

Finally my deepest appreciation goes to the persons pictured within this book, who have lost everything, spouses, siblings, children, and parents, and were able to start again in this wonderful country. The United States allowed them the freedom to grow again. They raised new families and educated them, and although they were never able to talk about the horrors they saw, they kept their religion, sense of humor, music, dance, and respect for one another.

INTRODUCTION

The Armenians of New Britain, who were living in their native historic Armenia, came from cities, villages, and farms. They came from small interwoven communities, full of love and families. Then they came from refugee camps in Syria and Lebanon and orphanages in Bulgaria, Greece, Lebanon, Syria, and other places. They were rescued from the deserts of Deir E Zor, where they left their dead children, mothers, brothers, and sisters. The men had already been taken away. Some were educated in European universities, some attended schools run by their churches or by missionaries, and some were not educated.

These are the descendants of the mighty Urartu, the descendants of Noah's Ark, the children of Mount Ararat: the Armenians!

One of the world's oldest civilizations, historic Armenia extended to the Caspian Sea in the east, to the Black Sea in the north, and to what is now northern Iran. It also included Syria, Cappadocia, and Judea (with Jerusalem), which were briefly vassals of the empire created by Tigran the Great in the first century B.C. The book of Genesis attests that Armenia's Mount Ararat is where Noah's Ark came to rest. Between A.D. 1080 and 1375, the independent Armenian Kingdom of Cilicia was formed by Armenian refugees fleeing the Seljuk invasion of Armenia. It was located on a long swath of the Mediterranean Sea in what is today Turkey.

Proud of their heritage as the first nation to adopt Christianity in the year A.D. 301, the Armenians became a nation of survivors. They lived for centuries in their own kingdoms until the Ottoman invasions in the 1200s. After that, they became second-class citizens in the Ottoman Empire. Following World War I, the Independent Republic of Armenia existed for a brief period between 1918 and 1920. This was a very small part of what had been Armenia, and tragically it left the most historic region of Mount Ararat in present-day Turkey.

They had been attacked many times before the massacre of 1895, when many of them were killed. However, the Armenian Genocide of 1915 was designed to eradicate all traces of this ancient nation. Of the three million–person population living in Turkey at that time, more than one and a half million persons endured unspeakable horrors and were brutally murdered, raped, or forced into Moslem harems. Their churches, which were the center of their lives, were destroyed, their homes pillaged and burned, and families were forever separated and destroyed.

The book *Ambassador Morgenthau's Story* by Henry Morgenthau, American ambassador to Constantinople from 1913 to 1916, originally published in 1919 by Doubleday, Page and Company, states on page 301 in chapter XXIV, titled "The Murder of a Nation,"

The destruction of the Armenian race in 1915 involved certain difficulties that had not impeded the operations of the Turks in the massacres of 1895 and other years.

If this plan of murdering a race were to succeed, two preliminary steps would therefore have to be taken: it would be necessary to render all Armenian soldiers powerless and to deprive of their arms the Armenians in every city and town. Before Armenians could be slaughtered; Armenians must be made defenseless.

On page 303, it states,

Let me relate a single episode which is contained in one of the reports of our consuls and which now forms part of the records of the American State Department. Early in July 2,000 Armenian "ameles"—such is the Turkish word for soldiers who have been reduced to workmen—were sent from Harpoot to build roads. The Armenians in that town understood what this meant and pleaded with the Governor for mercy. . . . Yet practically every man of these 2,000 was massacred, and his body thrown into a cave. A few escaped, and it was from these that afterward another 2,000 soldiers were sent to Diarbekir. The only purpose of sending those men out in the open country was that they might be massacred.

According to page 306 of Morgenthau's book, "In some cases the gendarmes would nail hands and feet to pieces of wood—evidently in imitation of the Crucifixion, and then, while the sufferer writhed in his agony, they would cry: 'Now let your Christ come and help you!'"

Finally, it states on page 307, "Yet these happenings did not constitute what the newspapers of the time commonly referred to as the Armenian atrocities; they were merely the preparatory steps in the destruction of the race."

Because of this horror, America was the dream. The first Armenians had come to New Britain in 1892, five men who went to work in the local factories. New Britain at that time was known as the "Hardware City of the World." By 1896, that number had grown to 145 persons; these were all men. Their goal was to earn money and go back to their homeland and buy their farms. In some cases, they intended to stay in the United States and send for their families.

The largest group arrived in New Britain in the years between 1920 and 1940. By the year 1940, there were 2,702 persons of Armenian descent living in New Britain. The Armenians were a very tight-knit, close community, as often happens when families have been destroyed. Family became persons from the same villages or regions, members of the church, neighbors, and so forth. Most of them lived within the proximity of Lafayette, North, Sexton, Tremont, Willow, Clark, East Main Streets and Hartford Avenue.

One

THE FIRST ARMENIANS, WHY THEY CAME

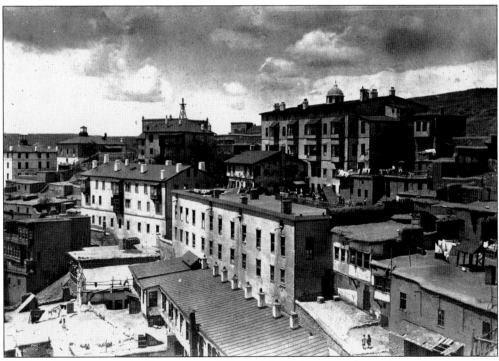

The best-known person in Kharpert was "Mustericks." Many years later, Armenian Americans realized this was Henry H. Riggs, the American missionary who served in Kharpert, the city that disappeared. This photograph taken in 1910 shows part of the West Side Upper Quarter: the Euphrates College complex, American Missionary Hospital, and the Protestant church. Partially in view is the upper portion of Soorp Hagop Armenian Apostolic Church. (Courtesy of Project SAVE.)

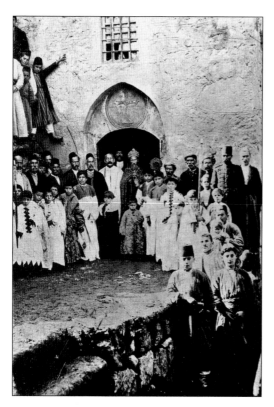

St. Nicholas Armenian Church in Ichme, Kharpert, Armenia, Ottoman Empire, was a traditional church where persons from that village worshipped. The priest is the uncle of Stephen Der Margosian, and shown is Lazar Manoogian, the first boy on the left side of the priest. Nigos Mazadoorian is the boy holding the candle on the right side. These are all relatives of New Britain community Armenians.

George Ohanesian served with the British Mounted Police on the island of Cyprus when his troop was chosen to participate in the golden jubilee celebration of Queen Victoria in England. After the celebration, the troops could choose any country in the British Empire to live in. Ohanesian chose Canada in 1895 and then came to New Britain. He married Ovsanna Guleserian, and they had four sons, George (who moved to Boston), Richard, Vaughn, and Dr. Jacob Ohanesian.

One of the earliest Armenian families was the Yagoobians. They came in the late 1890s, and their sons were born in New Britain. Seated are, from left to right, Asadour Yagoobian (holding baby Arzarouni "Bucko"), Paul, and Yeghsapert Yagoobian. Daughter Annie had not been born when this photograph was taken. In the rear are their relatives Asadour Markarian and his wife, Anna.

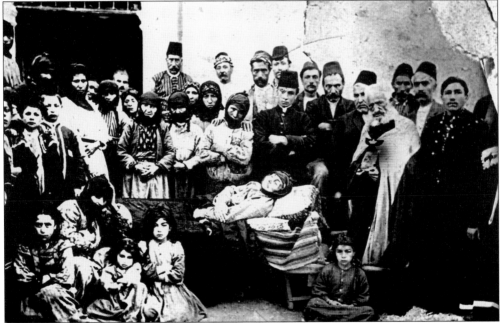

It was customary to have open caskets at funerals in the homeland. This is a group in Yegheke, Kharpert, probably around the year 1910. The Armenian women covered their heads just as their Moslem neighbors were required to. Also the men wore the fez before they were outlawed in Turkey in the 1920s.

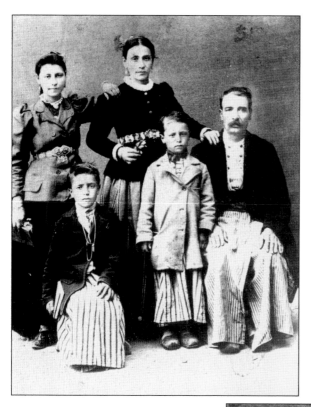

The Baronian family, who lived in what was called Veri Kaghak in Kharpert City, is seen in this photograph taken in the late 1800s. Mesak Baronian, father of Margaret Bagdigian, is the young boy in the center of this picture.

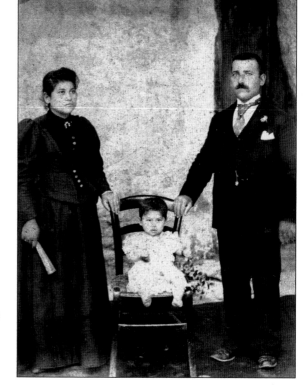

Members of the Yessian family, one of many Armenian families from Cyprus, are shown here in 1897 before they came to New Britain. Seen are, from left to right, Dirouhi Kevorkian Yessian, baby Shavarsh Yessian, and Garabed Yessian.

This photograph, taken in Mezireh, now called Elazig in Turkey, is of Aghavni Babian, mother of Angela Parnagian, and her husband who perished in the Armenian Genocide. As happened to so many persons, Babian was saved and immigrated to New Britain, remarried, and had a new family.

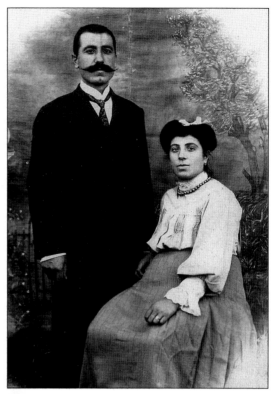

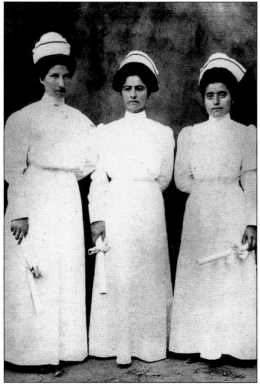

Hranoush Avedisian, right, has her diploma in her hand with two other Armenian girls at their nursing school graduation from Annie Tracy Riggs Hospital in Mezireh, Kharpert, on June 27, 1913. She married Ohan Geragosian of New Britain. Her son attorney Harold Geragosian has this original diploma framed and hanging in his office on West Main Street. She is the grandmother of state representative John Geragosian.

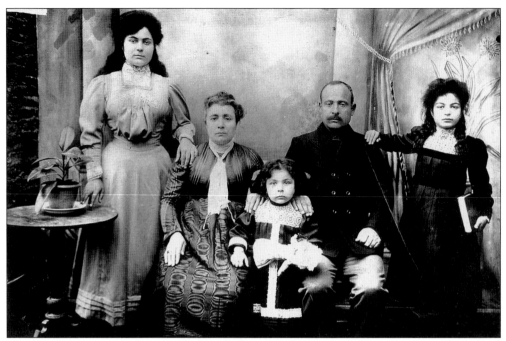

The Hovanessians are photographed with their daughters when they arrived at Ellis Island in 1912 from Cyprus. Pictured are, from left to right, Seran Hovanessian (Davidian), mother Miriam Hovanessian, Angel Hovanessian, father Rubin Hovanessian, and Mary Hovanessian (carrying the book). She later graduated from the New Britain Normal School (now Central Connecticut State University).

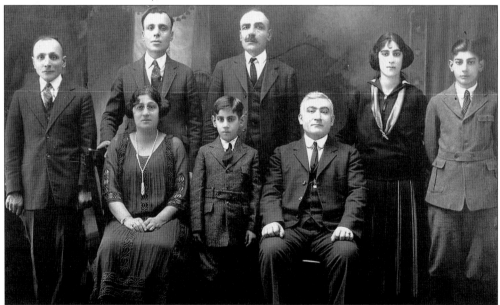

Another early group is the Simonian family, seen in this photograph. Pictured are, from left to right, (first row) mother Yeghsa, George, and father Peter Simonian; (second row) cousins Peter, Haroutuin (Harry), and Sarkis Simonian, and Mary and Edward Simonian, the children of Yeghsa and Peter.

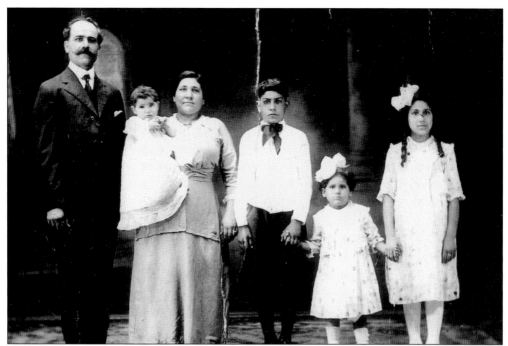

George and Aghavni Yeterian Kevorkian are together here with their family in 1917. Seen are, from left to right, George, baby Esther, Aghavni, Edward, Eppie, and Rani. Later twins were born to this family.

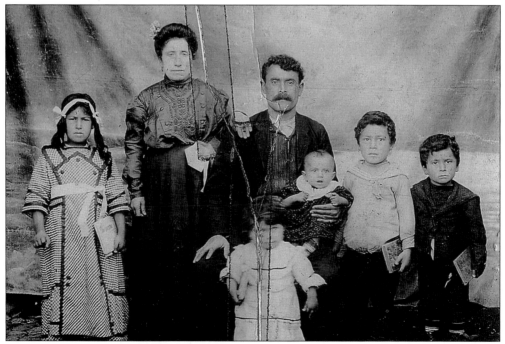

This is a photograph of the Deroian family from Hussenig, Kharpert, taken in 1913 and sent to Haroutun Deroian's brother who was living in Hartford. This entire family perished in the Armenian Genocide except for Maritza, shown on the far left at the age of eight.

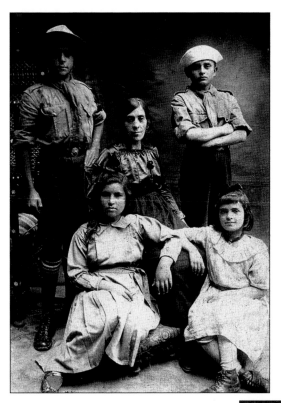

Seated in the first row on the left is Maritza Deroian Bogosian Ohanesian in 1920 at the age of 15. After she lost her entire family in the Armenian Genocide, she was saved by this kind Turkish family that had two sons and a daughter of its own. Young Armenian children were found in the desert and with families that had kept them or taken them from the death marches during the Armenian Genocide. They were then brought to orphanages throughout the Middle East. Ohanesian was found by the Armenian General Benevolent Union, which took her to Istanbul. Ohanesian's uncle, who was living in the United States, learned she had survived and sent for her to come to Connecticut.

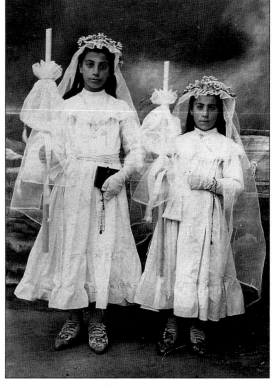

Armenians in their homeland worshipped in three Christian faiths, the Armenian Apostolic Church, which was the traditional original church of Armenia adopted by the country in the year A.D. 301, Roman Catholic, and Protestant. Shown in this photograph are Ernestine Tashjian Ohannessian and her sister Veronica Tashjian Thomas at their first communion in Mezireh (Elazig) in the Roman Catholic Church in 1912.

John Garabedian Alex and his wife, Lillian, knew each other in Urmia, Persia, and married after they arrived in the United States. He arrived in 1915, and Lillian came in 1917. They are here with their children in 1930. Seen here are, from left to right, (first row) Carroll and Norman; (second row) Sophie and Charles. Armand is the baby in the arms of his father. Their name was actually Garabedian; however, at Ellis Island, the immigration officers could not spell it, and so they took the name of Alex.

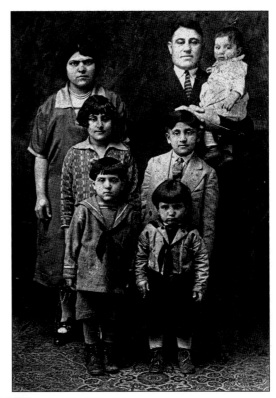

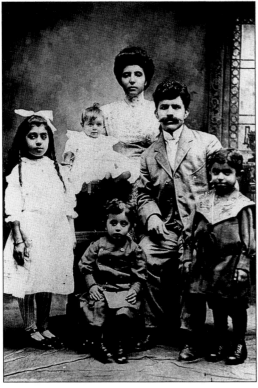

Standing in the rear of this photograph is the grandmother of Queenie Hovhanessian, Aghavny Semonian, with her husband, Garabed, and their four children. Aghavny was pregnant with her fifth child when they returned to Turkey and got caught in the Armenian Genocide, and she lost her husband.

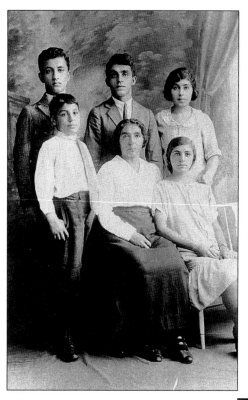

Seen here are the Semonians when they returned to the United States a second time. They had survived after the death of their father with a Turkish family that gave them safe haven for eight years. Their mother cooked and cleaned for this family. Mother Aghavny told her story of being from New York to the American consulate, and they were finally allowed back into this country.

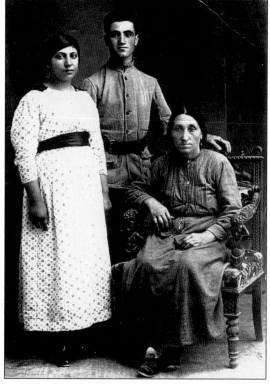

Charles Garabed Hovsepian was serving with the volunteers from New Britain under Gen. Edmund Allenby in World War I when he went looking for Armenian Genocide survivors in Syria. On the left is Mary Hovsepian Mooradian, and on the right is one of the Frankian family members. Charles was looking for any survivors when he saw Mary's name and village on the door where she was living. He knew she was his first cousin, and when he returned to America, members of her family who were living in New Britain brought her here.

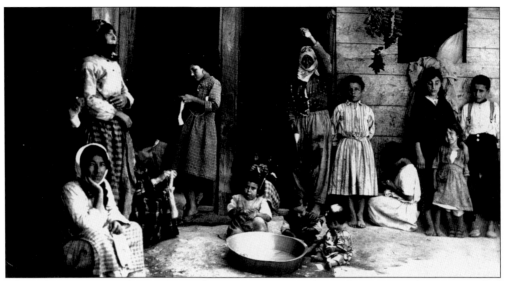

This refugee camp in Aleppo, Syria, where many survivors from Kharpert were living was called Tutunkhan. Literally translated to English, this is "Tobacco Inn." They did any kind of work they could to feed themselves and their families. (Courtesy of Project SAVE.)

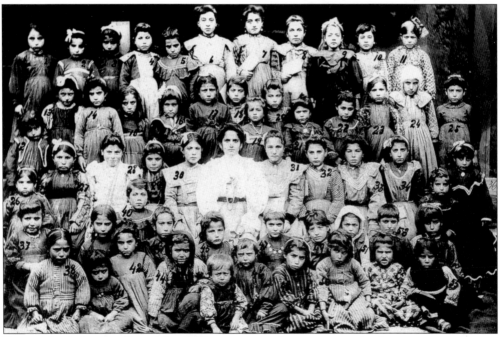

During the Armenian Genocide, children were saved in some cases by American missionaries. Siranoush Simonian Hovsepian was found in Elazig, taken to the orphanage in Kharpert City, then to Beirut. No one wanted these children. They were then transported to Istanbul by a ship, which was thought to have been sunk. When they arrived in Istanbul, the Armenian community had already performed a 40-day requiem mass for them. When they saw the children, another mass was held celebrating their safe arrival. However, the children had to leave Istanbul because the local Turks were stoning them. They then went to Greece. There is another photograph of the boys of this same orphanage. No. 42 is Siranoush Simonian, who lived on Tremont Street.

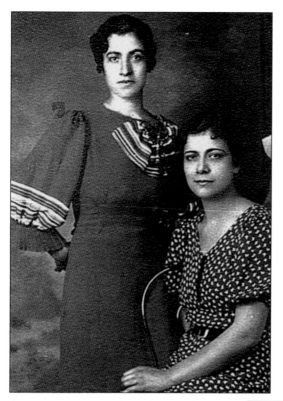

Esgouhi Simonian was one of the best Armenian dancers in this community. She was orphaned along with her sisters, Sirvart and Siranoush Simonian Hovsepian, during the Armenian Genocide. They were in an orphanage for many years and arrived in New Britain in March 1932. In World War II, Sirvart worked the night shift at Pratt and Whitney.

Brothers Krikor and Mardiros Maljanian are in this photograph in 1914. Mardiros came to New Britain in 1906 and worked in the New Britain factories. Krikor returned to Ichme, Kharpert, shortly after this picture was taken. The villagers were impressed with his suit and binoculars that allowed one to see into the next village from the heights of Ichme. He was captured there, marched out, and executed. His brother Mardiros (Martin) went to Westboro, Massachusetts, in the early 1900s as a barber. His son John married a New Britain girl and is a member of the New Britain community.

Khachadour "Dick" Der Bagdasarian (right) is with Krikor Derderian from the village of Yegheke, Kharpert. This photograph was taken in Aleppo, Syria, on April 16, 1922, after they escaped from Turkey. He was in the death march with his mother when she gave him to an Arab. He tended sheep for the Arab for seven years before he ran away back to their village of Yegheke, now called Aksaray. His father, an American citizen, finally brought him to this country.

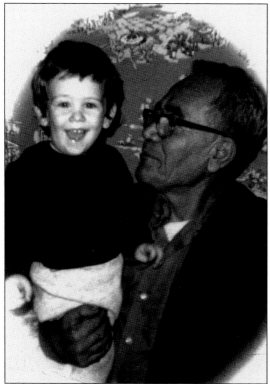

Khachadour Der Bagdasarian looks with pride at his grandson Rainer. For many years, he ran a tailor shop on North Street and was known as "Dick the Tailor." He managed to send his daughter Mary to Central Connecticut State College, his son John to Harvard University and the University of Connecticut Law School, his son Ara to Yale and Stanford Universities, and his son Nshan to the University of Pennsylvania.

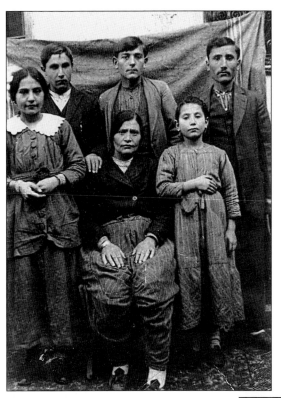

This is members of the Garabedian family after they escaped the Armenian Genocide in Aleppo, Syria, in 1922. In this photograph are, from left to right, (first row) Elizabeth (Yeghsa) Garabedian, mother Derief Garabedian, and Vartanoush Garabedian Danielian; (second row) Hagop Garabedian, Toros Der Torossian, and Reupen Garabedian.

This photograph was taken in Aleppo, Syria, in approximately 1923, prior to the Garabedians leaving for the United States. Seen here are, from left to right, (first row) Derief and her son Hagop Garabedian; (second row) Elizabeth (Yeghsa) Garabedian Der Bagdasarian and Anna Garabedian and her husband Reupen Garabedian. Immigration did not allow them to come to the United States, because of their age; they later went to live in Marseilles, France. At the right in the rear is Vartanoush, who moved to Lawrence, Massachusetts, after coming to New Britain.

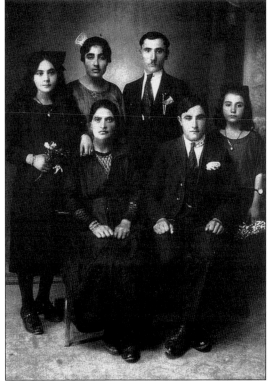

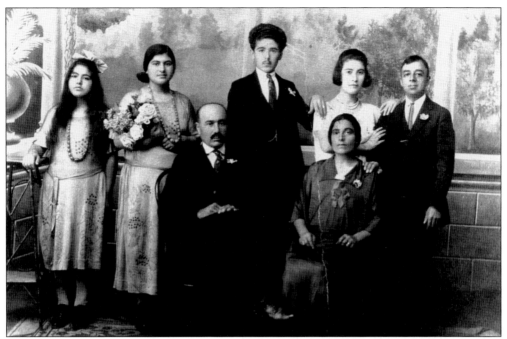

Many men went back to Aleppo from New Britain to search for their surviving families in the refugee camps. When families were not allowed back into the United States because of the immigration laws, they went to Canada, Cuba, or Mexico. This family photograph of the Bargamians was taken in Mexico in 1927, prior to their coming to the United States. Pictured are, from left to right, (first row) Barghig Bargamian and his wife Akabe Bargamian; (second row) Rose Bargamian Shahverdian, Zarouhi Bargamian Garabedian, Kachadour Bargamian, Baidzar Salyandjian, and Mesrop Boghosian.

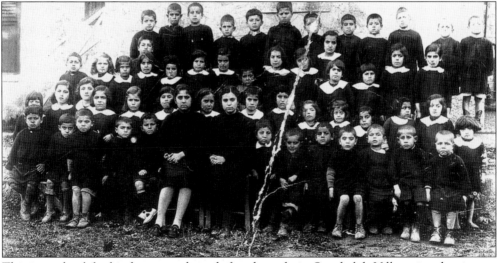

This is a school for kindergarten through fourth grade in Sogukolok Village, in what is now Turkey. At the time this photograph was taken in the 1930s, this area was part of Syria. It was later turned over to Turkey, and in 1938, the Yirigians were deported to Beirut, Lebanon. Sarkis Yirigian is the first person on the left in the front row. He immigrated to the United States in 1960.

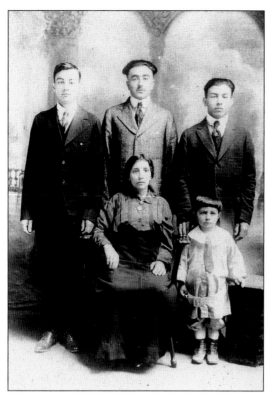

The Hovhanessian family was living in New Britain in 1910, before the Armenian Genocide. Shown here are, from left to right, (first row) mother Sarah Hovhanessian with young Martin Hovhanessian; (second row) Hagop Hovhanessian, father Bagdassar Hovhanessian, and brother Charles Abajian.

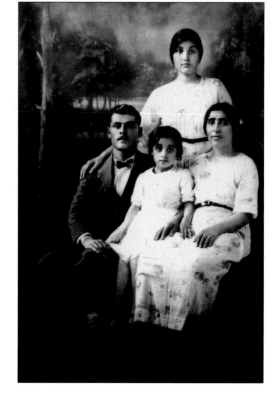

This photograph was taken in 1924 after they arrived in the United States. Kandap "Catherine" Sarkessian is seated front, right, with her daughter Helen Mary Jacobs. Standing in the rear is Seran Sayad.

Toros "Tom" Garabedian was married only a few years when he left his wife Dirouhi Der Torossian Garabedian, son Hagop, age two, and daughter Elizabeth, age six months, for the United States in 1909. He planned to return and buy land for farming. Meanwhile, the Armenian Genocide started; his wife managed to save herself and her children and get to Aleppo, Syria. He went back to look for his family and found them alive in Aleppo. He brought his wife and daughter to the United States in 1924, but his son was overage, and immigration authorities did not allow him to return with his father. Hagop went to France and studied tailoring. It took four more years for him to enter this country.

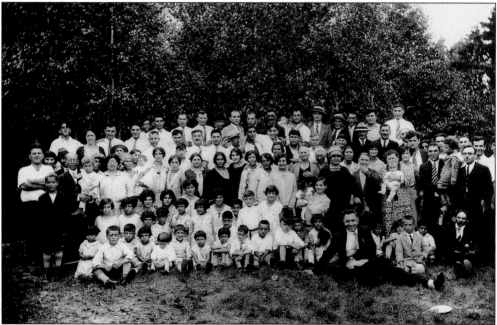

Village groups kept together after they arrived in the United States. This is the Garmery Benevolent Association picnic held in 1928. Garmery was a village in the province of Kharpert. It had a large picnic every Labor Day, one year in New Britain and one year in Salem, New Hampshire, where most of the survivors lived.

Baidzar Salyandjian Boghosian was born in Gerason on the Black Sea. During the Armenian Genocide, she, along with her mother and sister, were on the death march in the desert. A Turkish soldier pulled her away from her family, because of her beauty, and took her home to be a "handmaiden," as written by her daughter Hasmig Boghosian Sillano. After two years, the Protestant missionaries gathered all the Armenian orphans they could find and took them to orphanages. She was taken to an orphanage in Corinth, Greece.

Elizabeth Yegsa Mazadoorian was born in Yegheke, Kharpert, to Dado and Lucig Der Bagdasarian Aharonian. She started out with her mother and uncles in the horrible death marches but managed to survive. After living in orphanages, she reunited with her father in America in 1928. She and her husband, Nighos, had two sons, Deacon Charles and attorney Harry Mazadoorian. Through the parents' personal example, guidance, and sacrifice, both sons graduated from Yale.

Two

LIFE IN AMERICA

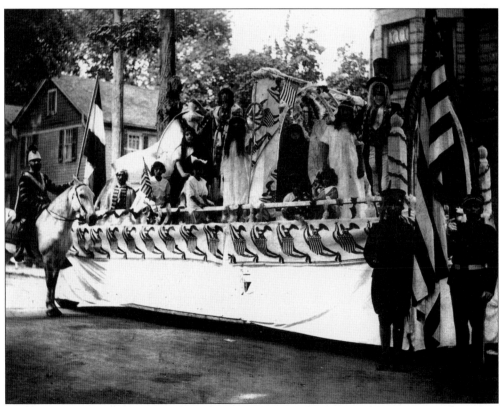

The Armenians had a float in the first Armistice Day parade of November 11, 1919. In the center with the crown is Seranoush Davidian, depicted as the queen of Armenia. George Depoian of Lyons Street is dressed as Uncle Sam on the far right.

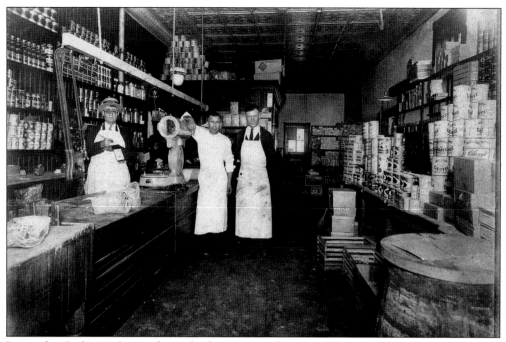

Located on Lafayette Street, this is the first meat market owned in New Britain by an Armenian. Owner Sarkis Der Abrahamian is on the left, an unidentified person is in the middle, and John Hovhannes Der Abrahamian is on the right.

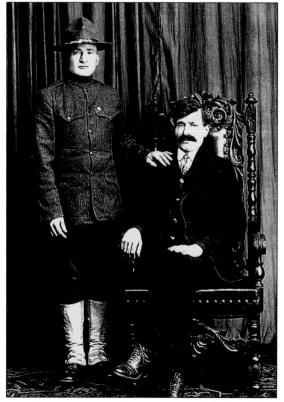

John Hovhannes Der Abrahamian, seen on the left in his army uniform during World War I, is with his brother Sarkis. Sarkis ran a meat market and grocery store for many years on Lafayette Street.

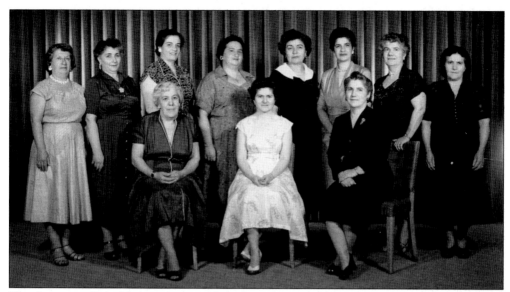

The Armenian Relief Society was established in 1910 to provide educational and humanitarian assistance to Armenians throughout the world. There are chapters in every country where Armenians reside. It also funds and operates a three-credit Armenian summer studies program at the University of Connecticut. Pictured from left to right are (first row) Irene Atamian, Lalezar Varjabedian, and Haigouhi Boornazian; (second row) Victoria Armaghanian, Youghaper Gourghigian, Azniv Kerkian, Melene Papazian, Rebecca Derderian, Stella Rustigian, Sarah Emerzian, and Margaret Boyajian.

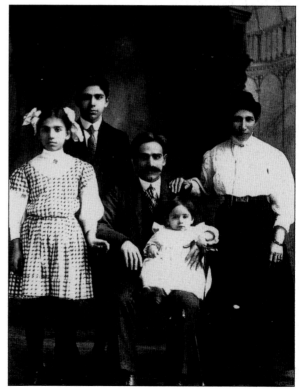

The Bogosian family was in the United States in 1909. Seen here are, from left to right, Helen Hripsime Bogosian Depoian, John Bogosian, father Kazar Bogosian with one-year-old Elizabeth Bogosian Chaglasian in his lap, and mother Kacher Bogosian.

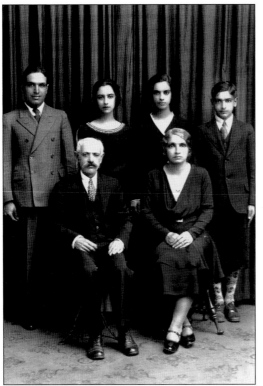

Zakar Bogosian is shown here with his family. He owned the first Armenian restaurant on Lafayette Street in the 1920s. This was very popular because of the large number of bachelors who had come to New Britain to work without their families. Standing are, from left to right, his son Aram; daughter Ruth, who, during World War II, served in the all-women division of the U.S. Navy, Women Accepted for Volunteer Emergency Service (WAVES); daughter Mary; and son Henry. Seated is Zakar Bogosian with his wife, Baidzar.

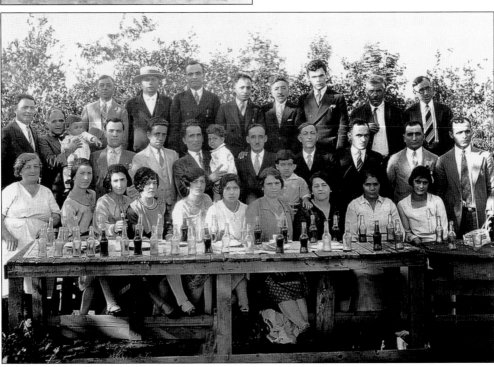

This is a picnic gathering of the survivors from the village of Ichme, Kharpert, in one of the New Britain–area farms in 1927.

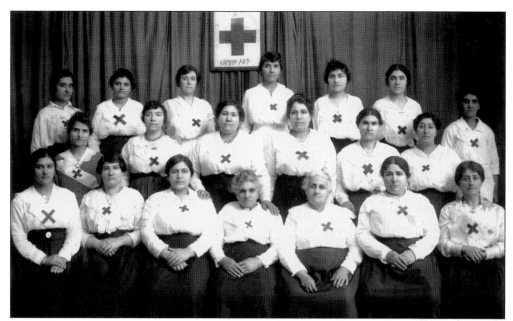

The Armenian Red Cross in the United States helped orphans and refugees following the Armenian Genocide in its homeland. Identified in this photograph from 1920 are Ovsanna Ohanesian (first row, far right) with Takoohi Hartunian next to her, Araxie Edgarian (second row, far left), Aghavni Kevorkian (second row, third from left), Yeranig Yeterian (third row, second from left), and Rose Jacobs (third row, fifth from left).

The family of Ohannes John Garabedian gathered for this photograph in 1938. Standing are, from left to right, Ohannes, Hayasdan Garabedian Garoyan, Haige Garabedian, and Elizabeth Garabedian Boyajian. Seated with her little daughter Julie Garabedian Ashekian is Satenig Krikorian Garabedian.

Humor was always a part of the lives of the Armenian community. These are the "Three Musketeers," photographed in 1920. Seen are, from left to right, Ohan Nazarian, unidentified, and Nerses Sarkessian.

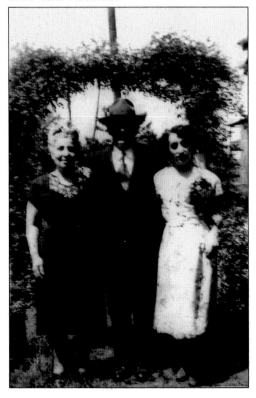

Walnut Hill Park was the site of many family pictures. Standing here are, from left to right, Kandap "Catherine" Sarkessian, Nerses Sarkessian, and Kandap's daughter Helen Mary Jacobs.

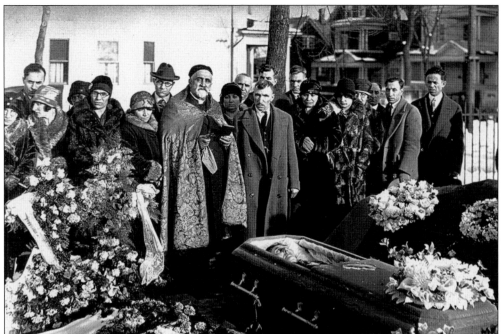

This is the funeral of Sultan Soukyasian, who was run over by an automobile while crossing the street very soon after she arrived in the United States in 1926. It was common to have open caskets in church and at the cemetery. Most of the people attending the funeral were from her home village of Garmery in Kharpert.

Fr. James Shahrigian, newly ordained in the Roman Catholic Church, served briefly at St. Mary's Church in New Britain in the 1920s. He later went to a parish in Louisiana.

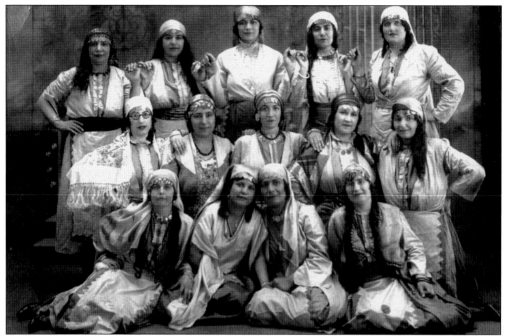

This Armenian dance group in costume is photographed in the early 1930s. Seen here are, from left to right, (first row) Yegsa Mazadoorian, Zavart Melikian, Ovsanna Harutunian, and Ovsanna Hovhanessian; (second row) Ernestine Ohannessian, Arshalous Hoosigian, Sirvart Simonian, Maritza Bogosian, and Vartouhi Yessian; (third row, holding little fingers as when they dance) Mary Mooradian, Arshalous Manoogian, Esgouhi Simonian, Siranoush Hovsepian, and Siranoush Azarigian.

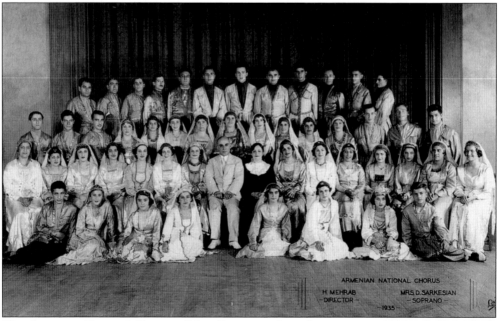

The Armenian National Chorus of New Britain performed a concert in 1935 with H. Mehrab as the director.

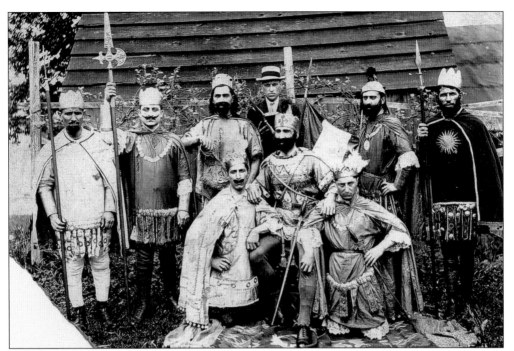

John Bogosian, standing third from the left, is part of this group of Armenians from New Britain in a drama. The best entertainment in those days was created by individuals. This photograph was taken in the early 1920s.

Almas Eknoian, center, managed to save one son after losing her husband and two daughters in the Armenian Genocide. She started a new family in New Britain. Michael is on the left, and Elizabeth Eknoian Wojculewicz on the right. Her grandchildren Sarkis Jr. and Roxanne are the children of her daughter Theresa Eknoian Khazarian, not in this picture.

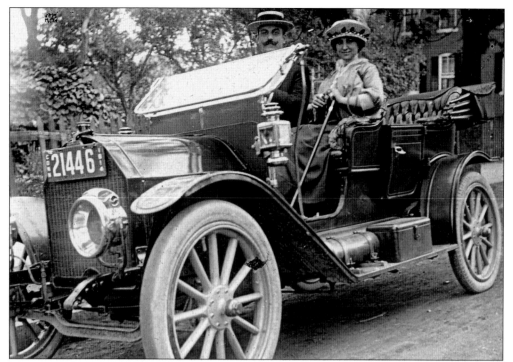

Harry Karekin Kevorkian was one of the early real estate agents in New Britain. He is photographed here with his wife, Mary, in their first car in 1914.

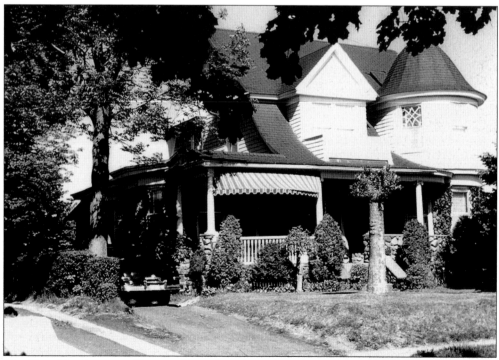

The Kevorkian house on Tremont Street has always been known for its beautiful architecture.

Mary Mooradian, M.D., was the first Armenian doctor to practice medicine in New Britain in 1913. Later in 1922, Dr. Moses Kupelian started his practice in New Britain.

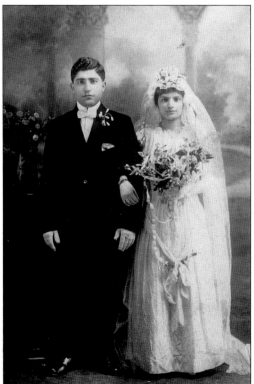

Manuel and Yeranig Mooradian Yeterian are photographed at their wedding, held in New Britain in 1915.

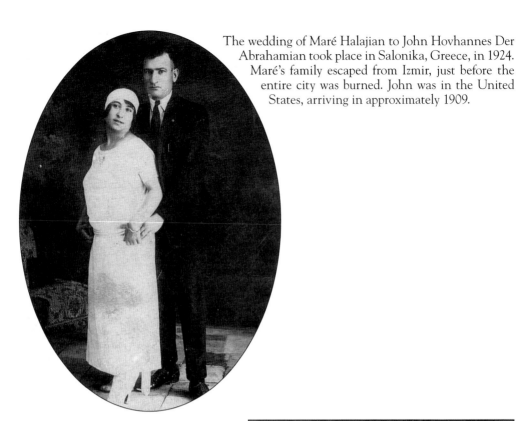

The wedding of Maré Halajian to John Hovhannes Der Abrahamian took place in Salonika, Greece, in 1924. Maré's family escaped from Izmir, just before the entire city was burned. John was in the United States, arriving in approximately 1909.

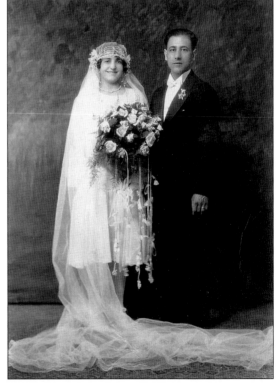

Shavarsh and Vartouhi Pilibosian Yessian were married in St. Stephen's Armenian Apostolic Church in 1928. Shavarsh was living in New Britain when he met his future bride in Cambridge, Massachusetts. She was born in Ichme, Kharpert, survived the Armenian Genocide, and was living with her uncle, who found her alive in an orphanage and brought her to the United States.

Seen here are Ovsanna Manoogian Hovhanessian and her husband, Hagop Hovhanessian, in their wedding photograph. As it was in so many cases, Ovsanna lost both her parents at the age of five in the Armenian Genocide, and she was put into an orphanage. Hagop, after seeing her picture, knew that he wanted to marry her, so he sent for her to come to America. Hagop ran a barbershop on Commercial Street for many years with Armenag Hoosigian.

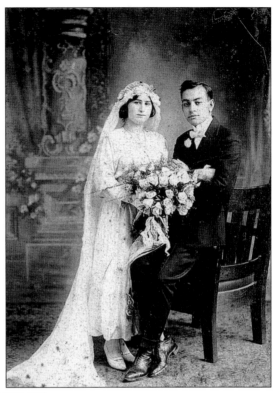

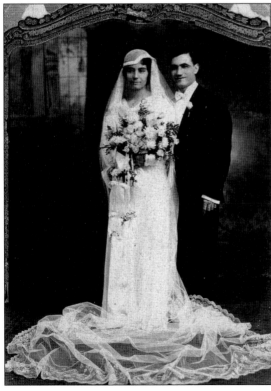

This is the wedding photograph of Siranoush Simonian and Garabed Hovsepian in 1934 at St. Stephen's Armenian Apostolic Church when she finally arrived in the United States.

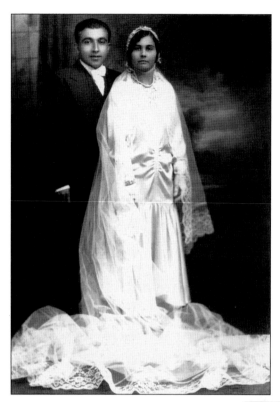

The wedding photograph of Yegsa and Nighos Mazadoorian in 1932 shows the beautiful dresses worn on those occasions. Weddings were very happy events, and most of the community participated in the festivities. In the early days, chicken and pilaf dinners at the reception would be served in the church hall by friends of the family. As the years progressed, weddings have become more elaborate.

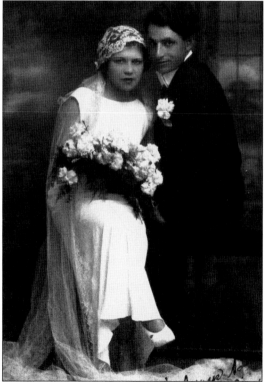

Margaret Baronian and Peter Bagdigian are shown here at their wedding on February 4, 1934.

40

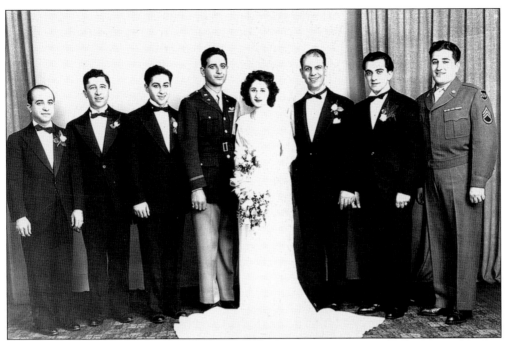

The wedding of Aram Otto Bayram and Julie Oshana on March 10, 1945, was the largest wedding ever held in New Britain with 800 attendees at the Stanley Arena on Church Street.

Three men from the village of Yegheke, Kharpert, came together for this photograph in the 1940s. Seen here are, from left to right, Harry Boyajian, Sahag Derderian, and Charles Garabed Hovsepian.

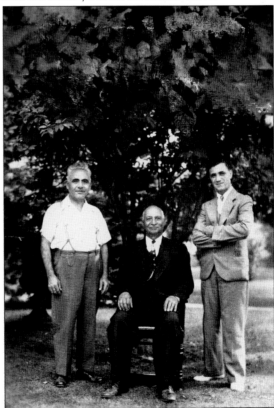

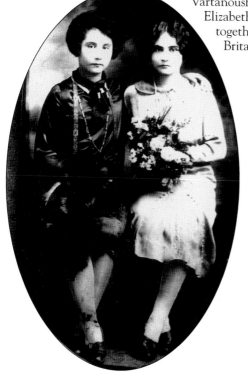

Vartanoush Garabedian Danielian (left) and cousin Yegsa Elizabeth Garabedian Bagdasarian are in this photograph together in 1925 after they finally arrived in New Britain in November 1924.

Seen here is Elizabeth Yegsa Bagdasarian with her daughter Mary, soon after her son Nshan was born. She was an excellent seamstress and worked all during the 1930s in what were called the sewing factories in New Britain. There were many coat and dress factories where women were working in those years prior to World War II.

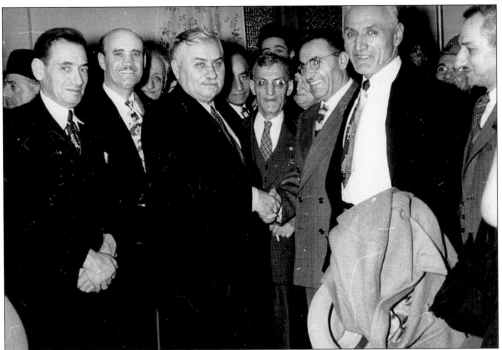

Hagop Garabedian, right, always remembered with pride the day that he shook hands with Gen. Dro Kanayan, who was one of the commanders of Armenian volunteer units during World War I. In the early days, to be Armenian meant one had the stamina to sit through long afternoon programs with speakers in the church hall.

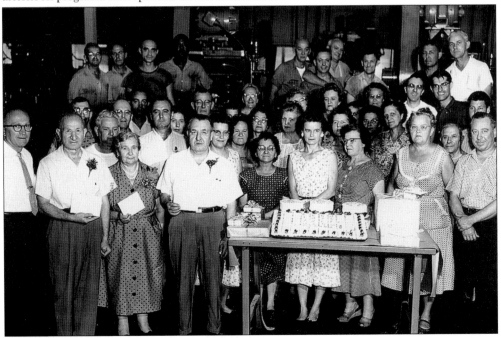

John Hovhannes Der Abrahamian worked for many years at the Fafnir Bearing Company. He is shown here, second from the left in the front row, at his retirement party in 1957.

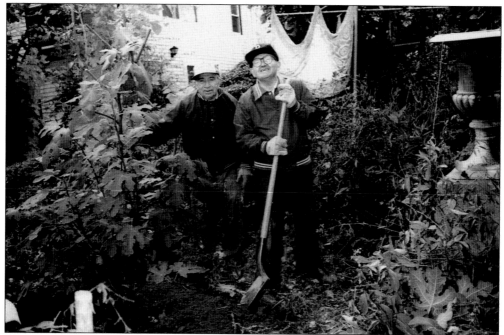

Most Armenians loved to garden and were very proud of what they grew. During the Depression years, the City of New Britain allowed families to use a part of Fairview Cemetery to grow vegetables. Shown in this photograph are Nighos Mazadoorian (left) and his son Charles uncovering the fig tree for the spring at their home on Clark Street.

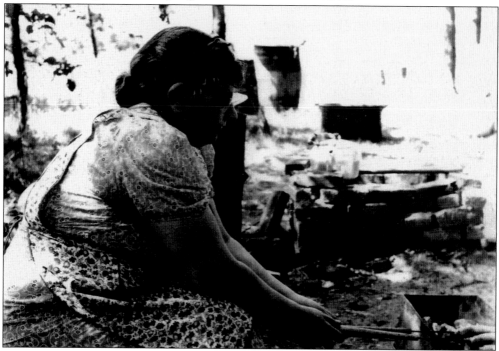

Yeranig Yeterian is cooking shish kebab over the fire in their backyard. This was a common practice in most Armenian families long before barbecues were so widely used.

Anna Terdjanian and her husband, Hougas, are seen here with their son Minas while in Malatya, Turkey. They had survived the Armenian Genocide and later left for Armenia in the 1940s. In the picture below, the entire Terdjanian family is shown with mother Anna and son Minas in the center of the front row in the 1960s.

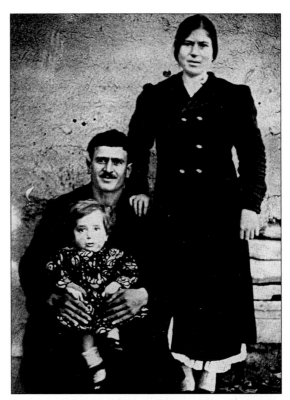

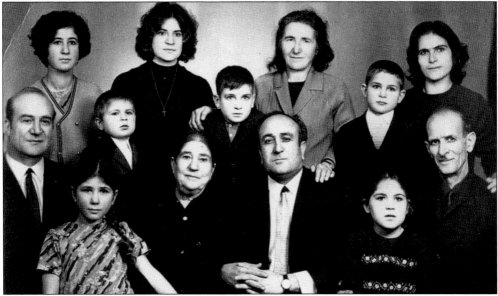

George Mardigian, famous restaurateur of San Francisco, was consultant on foods to the quartermaster general of the United States Army. He discovered camps of homeless Armenians while touring the army kitchens of Europe during World War II. When he returned, he mobilized communities here to sponsor them. The Terdjanians were brought here through these efforts and were headed to California. Their cousin in New Britain, Rose Azarigian Davidian, met the plane they were on and brought them back to New Britain.

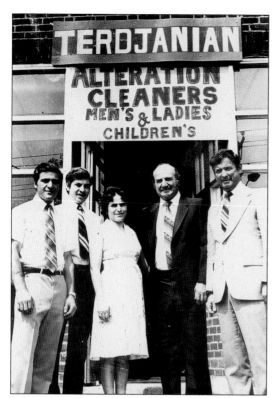

The Terdjanians owned a tailor shop on Farmington Avenue after they arrived in New Britain. Seen here are, from left to right, sons Serop and Harry, mother Mariam, father Bedros, and former New Britain mayor William McNamara.

The Idle Hour beauty parlor was owned by the Sarkessian sisters starting in the 1950s, first located at the corner of Main and Commercial Streets, and then moved across the street to the corner of Myrtle and Main Streets across from Lifshutz Department Store. Seen here are, from left to right, Mae Sarkessian Demetriou, Henry Schupak (an insurance agent who owned their building), and Janet Sarkessian Der Aprahamian.

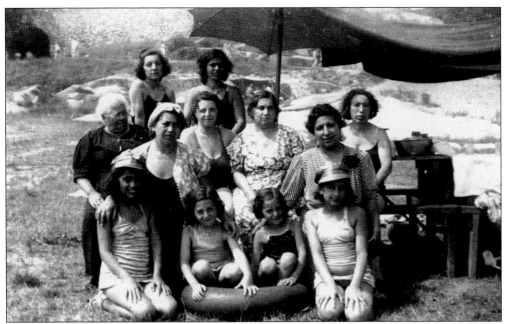

Summer months provided an opportunity for families to get together for excursions to the shore. Several families would pile into one car, and invariably there would be a flat tire due to weight. These were always fun times with plenty of food and play. This is Rocky Neck State Park in 1940.

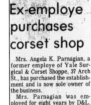

ANGELA PARNAGIAN
New Owner

Ex-employe purchases corset shop

Mrs. Angela K. Parnagian, a former employe of Yale Surgical & Corset Shoppe, 37 Arch St., has purchased the establishment and is now sole owner of the business.

Mrs. Parnagian was employed for eight years by D&L, and for the past 20 years was an employe of Yale Surgical.

She has 28 years of experience in the field of corsetry, bra and surgical fitting.

She resides at 99 Winthrop St. She has a daughter, Mrs. Christine Esposito of Hamden.

A statement announcing Mrs. Parnagian's purchase of the business said: "Now that Mrs. Parnagian is sole owner of Yale Surgical & Corset Shoppe, her undivided attention can be devoted to proper fit and expert consultation, which means so much to customer comfort and satisfaction in this highly specialized field."

The *New Britain Herald* ran an article on Angela Parnagian, who purchased the Yale Corset Shop in 1973 and ran it until her retirement in 1990. Her expertise in surgical fittings made her a valuable member of the community.

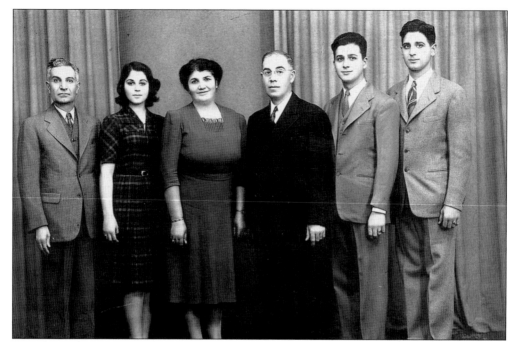

Amrah Bayramian, center, is pictured here with his family. He was one of the early founders of St. Stephen's Armenian Apostolic Church. In his private life, he owned the Epicure Store, first on Arch Street and then in Farmington. From left to right are a guest, Sarah Bayram Alverdy, Sherin Bayram, Amrah Bayramian, Warren Bayram, and Aram Otto Bayram.

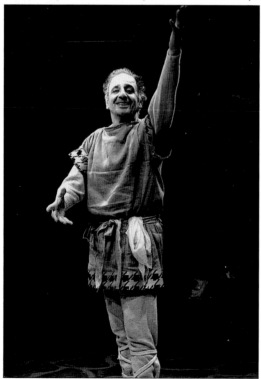

Otto Bayram was very involved in theatrical productions. He is seen here in his role as Don Quixote in *Man of La Mancha*, for which he won an award for best theater production.

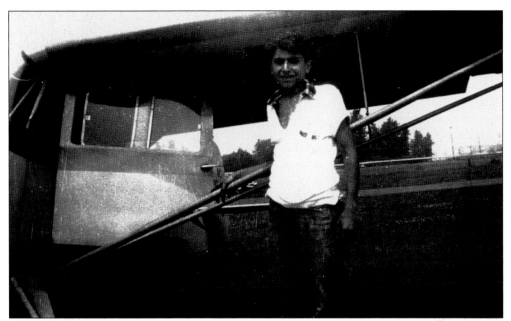

John Maljanian purchased a 1948 two-seat Aeronica Chief airplane in April 1953. He took lessons and received his pilot's license. Harry Mazadoorian is shown here at Brainard Field after flying with Maljanian over the New Britain area. The aircraft was sold in June 1953 when Maljanian was drafted for two years of military service.

Three of the four Bagdasarian children are photographed together in a formal picture in the 1930s: from left to right, John, Mary, and Ara. Their brother Nshan had not yet been born.

Elizabeth Der Hoosigian Yagoobian is with her children at her 80th birthday. She was born in the United States and returned with her family to Turkey and got caught in the Armenian Genocide. She lost everyone except for her brother. They were found in the streets of Elazig and taken to the orphanage run by the American Board of Missions. Seen here are, from left to right, Rose Apkarian, Elizabeth, Oscar Yagoobian, Charlotte Ohanesian, and Elizabeth Hillemeir.

Elizabeth Azarigian Vartanian, second from the right, and her husband, Charles, are with their friends Jacob Ohanesian, M.D., and his wife, Charlotte.

Ashod Shahverdian survived the massacre of Khoy, Iran, by the Ottomans in 1915 and came to New Britain in 1928. He had a self-taught musical talent. He worked in the factory by day but volunteered his talents generously. He participated in a concert by Mehrab in 1935 and directed two other major concerts in the 1950s and 1960s in addition to many musicals and plays held in St. Stephen's church hall. He also served as choir director.

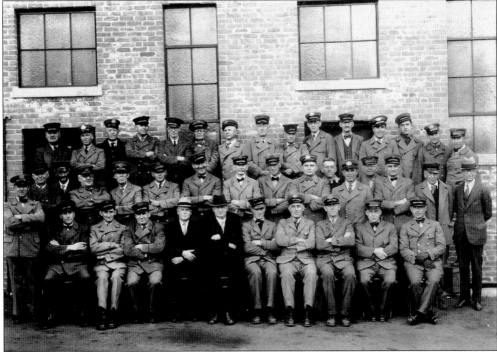

Nishan Kerekian was the first American Armenian to be employed by the New Britain post office in the late 1920s. He is in the second row, fifth person from the right.

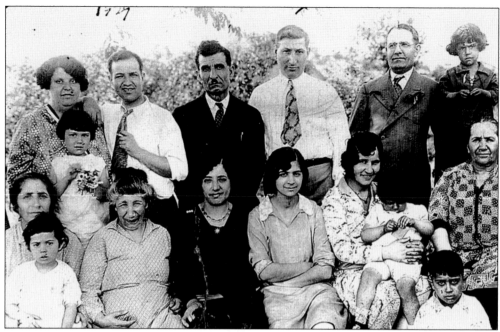

This photograph was taken in 1929 with a family that later moved to California. Seen here are, from left to right, (first row) Mary Kerekian Atashian on the knees of her maternal grandmother Mannig Chilingerian, two unidentified women, Araxie Chilingerian Kerekian, Maritza Bogosian Ohanesian holding Violet Bogosian Galazan, and Nazele Kerekian with her grandson Edward seated in front; (second row) Hatchig Arakelian with his wife and daughter Vartanoush Arakelian, unidentified, Mousheg Depoian, Kachadour Markarian, and Ann Bogosian Sadoian.

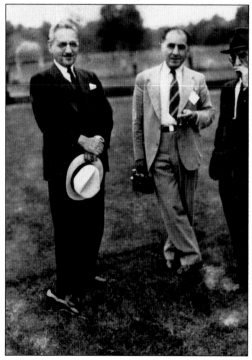

Tigran Sarkissian Serguis, center, was one of the community leaders in the 1930s to the 1960s. He is pictured here at the Armenian Youth Federation Olympics held at Willow Brook Park in 1946. Standing with him to the left is Simon Vratzian, prime minister of the Independent Republic of Armenia from 1918 to 1920.

Three

CLUBS, VILLAGE TIES, NEIGHBORS, FRIENDS

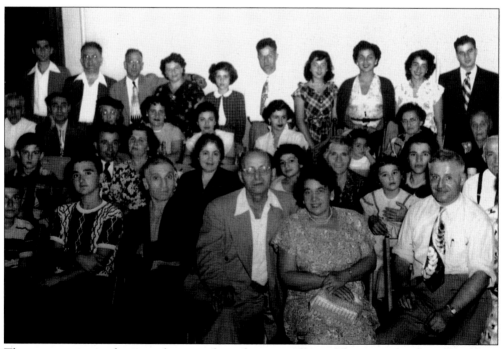

There were many gatherings of persons from the same villages. This is a group from the village of Ichme, taken in the 1940s.

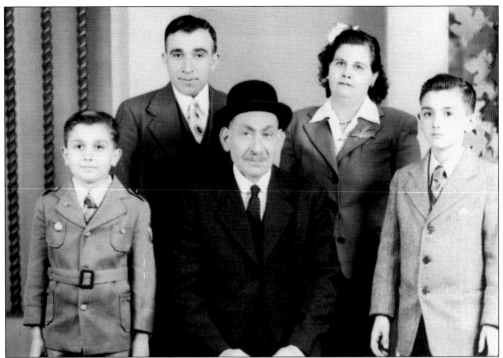

The Mazadoorian family had this formal photograph taken with sons Harry and Charles, father Nighos, mother Yegsa, and grandfather Dado Aharonian.

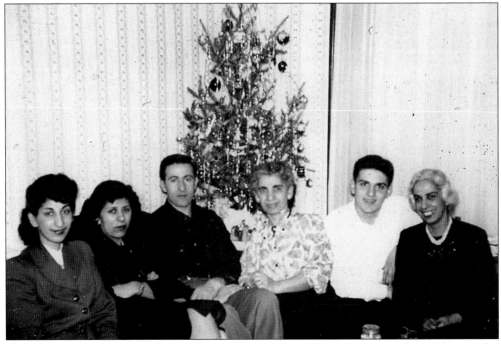

Christmas is always a time for families to get together. Shown here are, from left to right, Dorothy Depoian Cwikla, Violet Bogosian Galazan, Martin Depoian, Helen Depoian, Carl Chaglasian Jr., and Mary Bogosian.

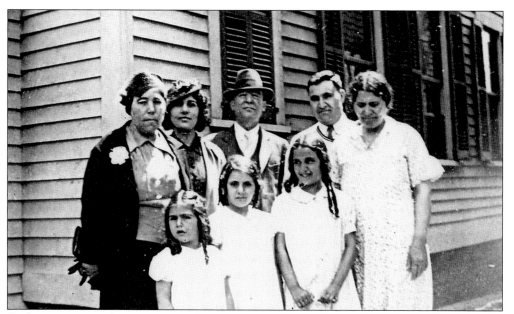

Godparents are very important in the Armenian tradition. They are usually the same family for generations. The Armenian equivalent to the best man and maid of honor were known as "godmother" and "godfather" to the newly married couple and also to their children. Godparents to the Garabedian children were Khachadour Sarkessian (the man with the hat) and Takouhi Sarkessian (far left).

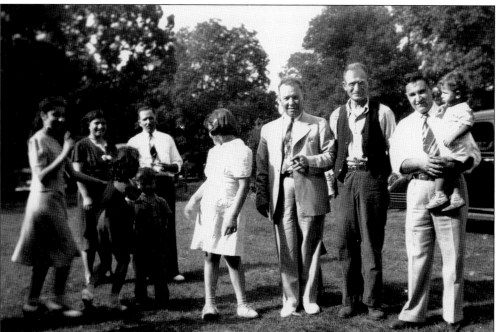

Every year, the families who came from the village of Garmery in Kharpert would hold a large outdoor picnic. Since most of the people were from New Britain or Massachusetts, it would be held here on alternating years. The Arzoians from that village, who had moved to California, came to this picnic in 1939.

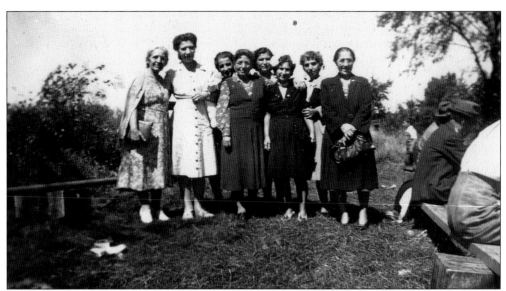

A few of the women who attended the village of Garmery picnic held in New Britain after World War II are shown here.

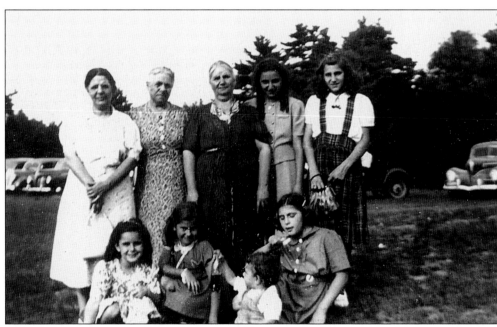

Village picnics were some of the most memorable events for the survivors who had come to the United States. The picnic of the people from Garmery in Kharpert was one of the largest held each year. This is a photograph of that picnic held in New Britain in 1939. People had come from as far away as California to attend this picnic.

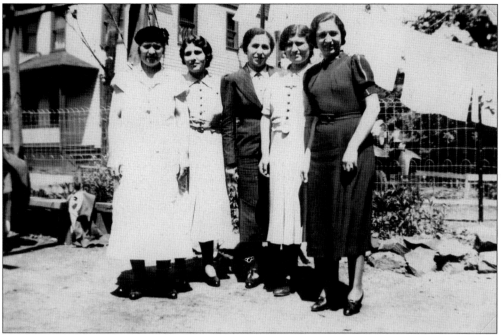

Families had come from New York to visit relatives on North Street in New Britain in the 1930s. From left to right are Dirouhi Garabedian, Rose Shahverdian, Shoushanig Kaprealian, Zarouhi Garabedian, and Seranoush Dedeian.

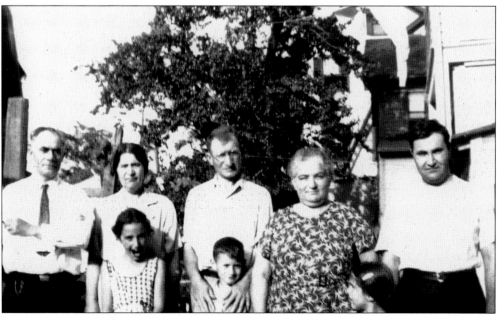

Long before there were any highways, families traveled back and forth to Massachusetts and New Hampshire to see each other. When one visited, it was a community event.

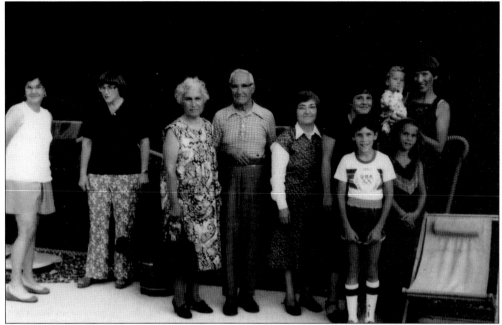

Josephine Midejean and her daughter, Jocelyn, from Marseilles, France, came to visit cousins in the United States in 1980. Seen here are, from left to right, Roxy and Helen Garabedian, Zarouhi and Hagop Garabedian, Josephine Midejean and her daughter, Jocelyn, and baby Kristofer Bagdasarian in his mother Renate Bagdasarian's arms. In front are Rainer and Sabrina Bagdasarian.

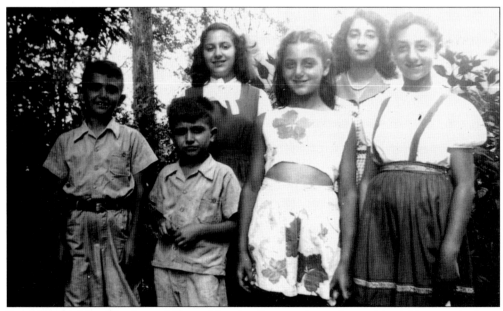

From left to right, Charles and Harry Mazadoorian are shown here with visiting cousin Lucy Pilibosian of Watertown, Massachusetts, and the three Yessian sisters, Mary, Lucy, and Roxie, in the 1940s.

Grace Der Abrahamian is photographed playing with her cousins Gregory (center) and Paul Der Abrahamian in the 1930s.

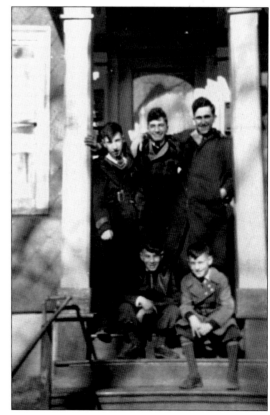

Hanging out at 82 Winter Street in 1942 are, seated from left to right, Arthur Simonian and Gregory Der Abrahamian. Standing are, from left to right, Paul Der Abrahamian, George Simonian, and Hratch Azarigian.

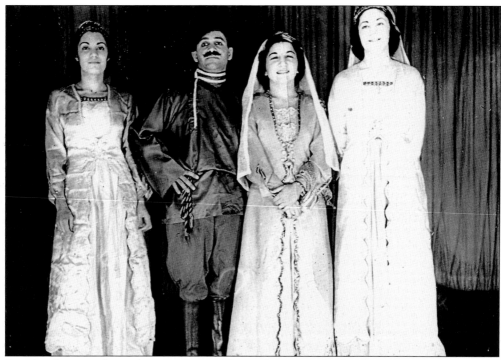

Standing here are the performers of one of the productions at St. Stephen's Armenian Apostolic Church Hall in 1938. Ashod Shahverdian is the male lead.

Picnics at the Sagherian and Bagdigian farms were very happy social events where families and young people came together to eat, drink, socialize, and dance. Second from the left is Shirley Kevorkian, and fourth from the left is Knar Edgarian Babayan at a picnic in the 1930s.

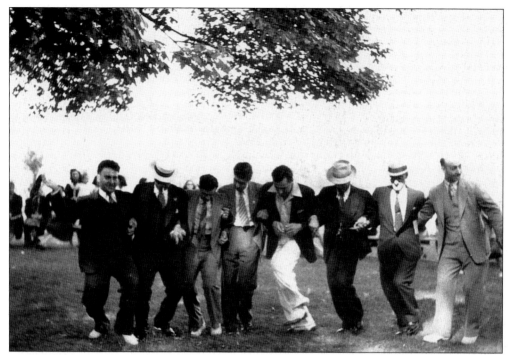

Manual Kasparian is leading a group of men doing the *shikhane* dance at an Armenian picnic in the 1940s.

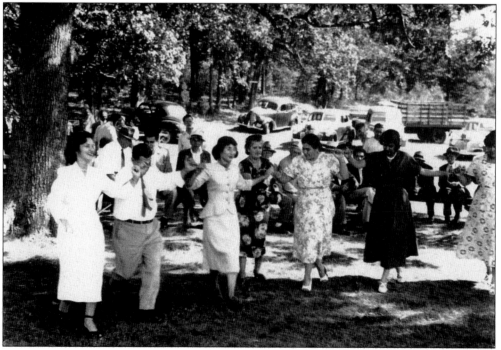

Traditional Armenian dances were performed by members of the community. Shown here is Agnes Barsoian Karanian leading the dance of the region of Sivas, called the *sepastazie* dance, at a picnic in the 1940s.

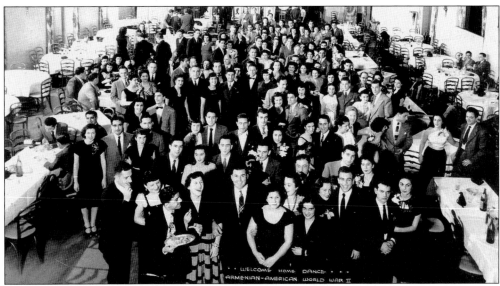

At the end of World War II, in November 1946, a very large welcome home dance was held at the Hotel Bond in Hartford to honor the many New Britain veterans who had served in the war.

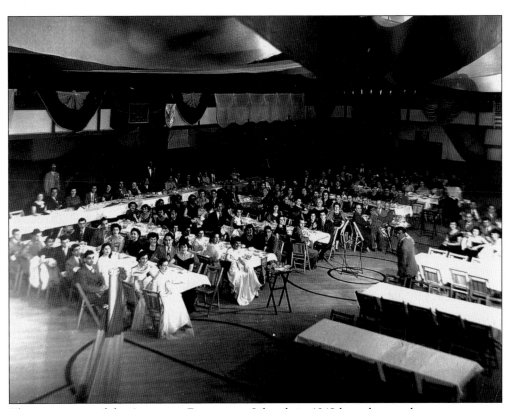

The convention of the Armenian Democratic Liberals in 1949 brought together many persons from the Northeast to New Britain. This is the final banquet held at the Stanley Arena, which was on Church Street, the site of many athletic events, weddings, and banquets.

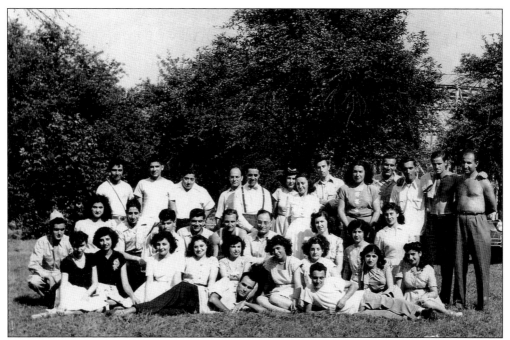

A very active group of young persons had a group called the Hye Society at the First Church of Christ Congregational. Group members are photographed here at one of the many social events they held during the year in the early 1950s. The pastor, Rev. Yervant Hadidian, Ph.D., second row center with glasses, was the group leader.

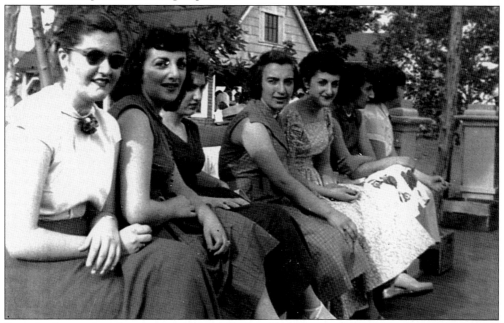

Friends often gathered at someone's house for fun. Usually a mother would prepare a wonderful bountiful table of food. From left to right are Roxy Garabedian, Mae Sarkessian Demetriou, Mary Bagdasarian Mooshagian, Hasmig Boghosian Sillano, and Janet Sarkessian Der Aprahamian in the 1950s.

Ohannes John Garabedian is seated with his wife Satenig Krikorian Garabedian at their 46th wedding anniversary in 1966. He had served with the Armenian volunteers under the allied command of Gen. Edmund Allenby in World War I. Ohannes, who had lost all his loved ones, met the sister of his friend Stephen Krikorian, who was serving in the army with him and was from the same village of Perchenk, Kharpert. He met his future wife at the orphanage where she was and brought her to the United States where they were married.

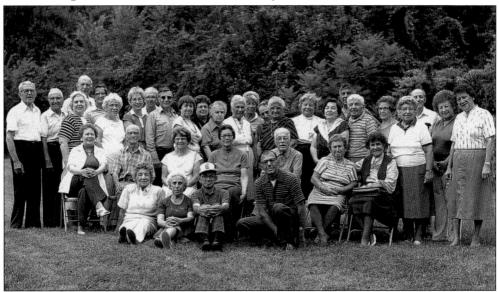

A very active group of seniors met every Wednesday afternoon at the Armenian Church of the Holy Resurrection to play cards and socialize. This is a photograph of that group taken in 1985.

Harry Badrigian is in this photograph with his wife, Rose Harmaian Badrigian. He was conductor of the Lentini Concert Band, which played at the music shell at Walnut Hill Park every week during the summer months. The band always played "My Wild Irish Rose," but on one occasion they called it "My Wild Armenian Rose" because his wife, Rose, was sitting in the front row. Harry contributed greatly to the music scene in New Britain by also playing clarinet with the New Britain Symphony.

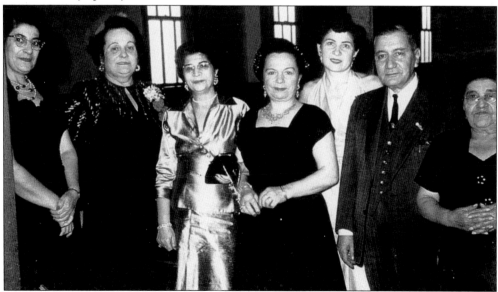

Banquets were often held to commemorate various events. This group is all dressed up for a special occasion in the 1940s. Seen here are, from left to right, Mary Atashian, Siran Davidian, Araxie Kerekian, a friend visiting from New York, Rose Parparian, Sarkis Shahrigian, and Hripsime Kaprealian.

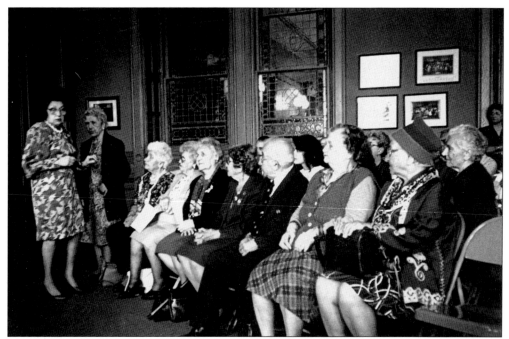

Anne Esaian organized the Genocide Commemoration Program at the state capitol in Hartford for many years. She is seen talking with Eliza Zakarian, an Armenian Genocide survivor, whose daughter Julie Tashjian served as secretary of the state of Connecticut. Seated are the survivors, who, except for one or two persons, are deceased today.

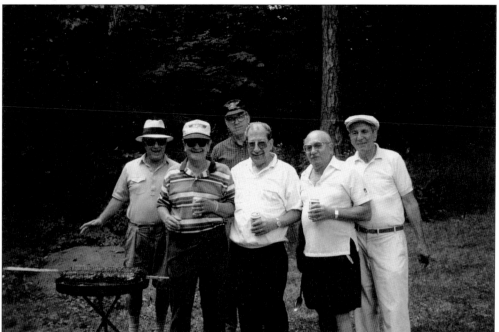

In 1995, these are master chefs cooking shish kebab at an Armenian Democratic Liberals Father's Day Picnic at the Quartette Club. Standing are, from left to right, Arthur Simonian, Jack Mansigian, Wilford Swisher, Richard Kallajian, Anthony Grano, and Charles Vartanian.

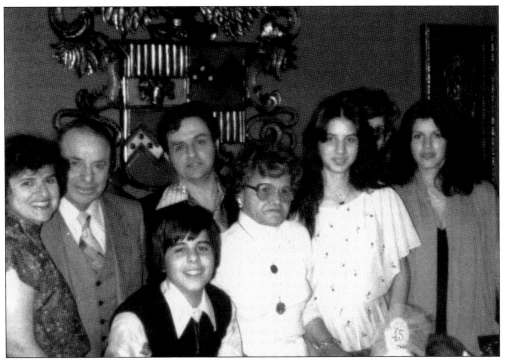

Family gatherings were always important events. Shown here are the Bagdigians, with their father and mother, Peter and Margaret Bagdigian.

Retired colonel Charles Alex is photographed here at a picnic with his sister Sophie Alex Elia in the 1990s.

Edward P. Simonian, who served as superintendent of the Fairview Cemetery, is shown here with his wife, Alice Hartunian Simonian, to the right and Maritza Bogosian Ohanesian on the left. As an active member of the Armenian Church of the Holy Resurrection, he was very instrumental in organizing the New Britain Armenian Seniors Group.

John and Roxie Yessian Maljanian celebrated their 50th wedding anniversary in 2006. They are seen here with Elizabeth Yegsa Mazadoorian, who always liked to say, "I was matchmaker." A marriage that lasted 50 years had a good matchmaker.

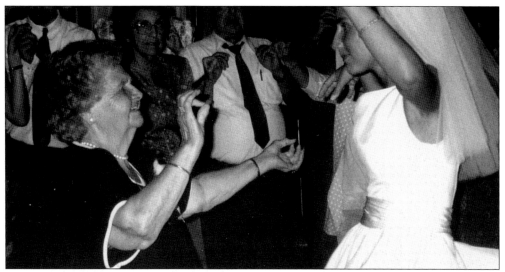

A wonderful old Armenian tradition is welcoming the bride by dancing her into the wedding reception. Lynn Mazadoorian is being danced in here by her grandmother Yegsa Mazadoorian.

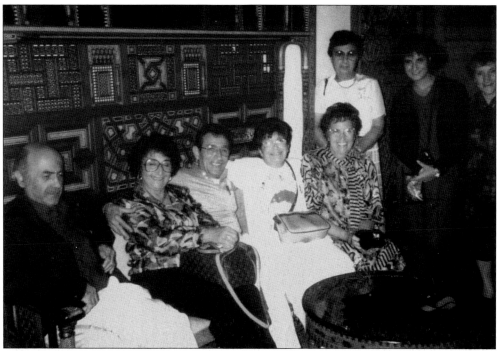

The Armenian diaspora is living in many countries of the world. In 1992, a group from New Britain visited Garbis Yazedjian, the Cairo jeweler, at the Mena House Hotel in Egypt. He developed the concept of making a gold cartouche spelling a person's name in Egyptian hieroglyphics.

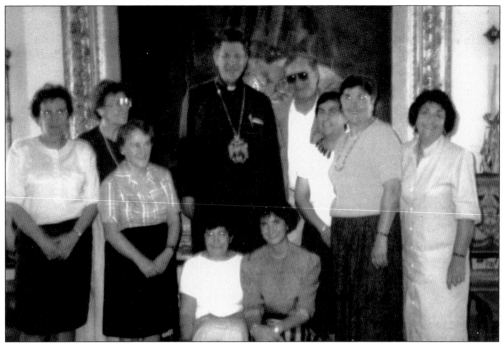

The Armenian community holds a very important place in the Church of the Holy Sepulcher in Jerusalem and the Church of the Nativity in Bethlehem. A group from New Britain visited the Armenian patriarch of Jerusalem, His Beatitude Archbishop Torkom Manoogian in 1992.

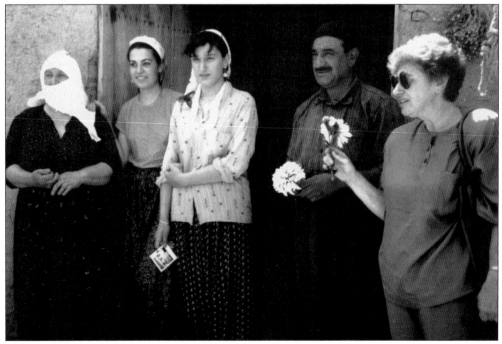

It was always interesting to travel with a group of American Armenians. One of the most memorable of these trips was to visit the villages in Turkey, where their families had lived. This photograph was taken in Garmery in 1989.

Rachel Abrahamian Boloyan is shown here standing in front of the entrance to the Armenian Church in Athens in 1992.

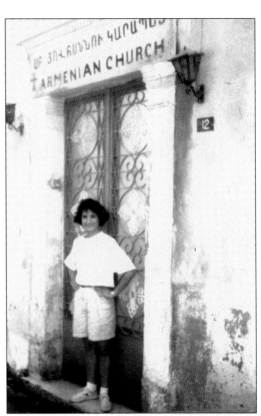

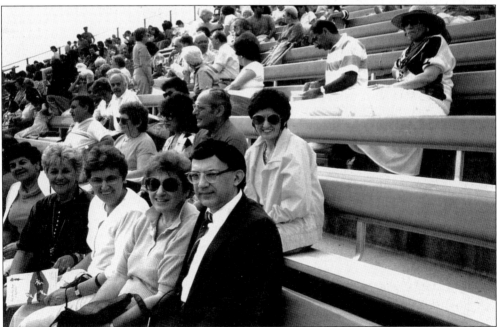

The annual Armenian Youth Federation Olympics brought together friends, old and new, from all over the United States to watch these games and renew acquaintances in a three-day event over Labor Day.

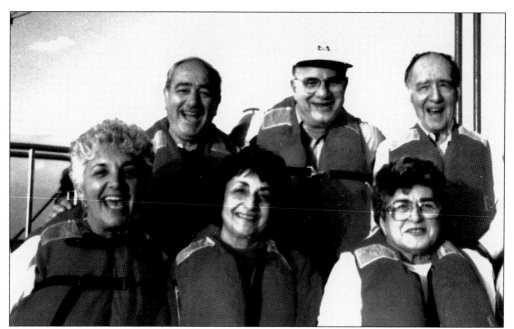

A very happy group from New Britain took a Caribbean cruise together in 1992. Here they are feeling silly during the fire drill. From left to right are (first row) Queenie Hovhanessian, Lucy Simonian, and Lucy Shabazian; (second row) Bagdasar Hovhanessian, Arthur Simonian, and Joseph Shabazian.

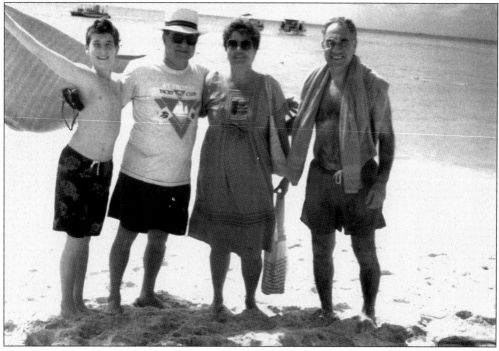

A day at the beach is always fun, but it becomes even more when it is with friends on a cruise to the Caribbean. This happy group was photographed in 1992. Seen here are, from left to right, Kristofer Bagdasarian, Arthur Simonian, Roxy Garabedian, and Ara Der Bagdasarian, M.D.

Four

THE CHURCHES

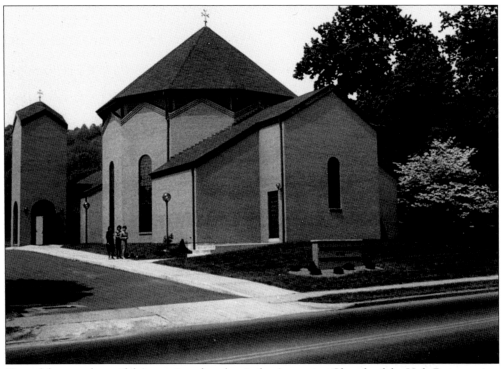

One of the most beautiful Armenian churches is the Armenian Church of the Holy Resurrection on Stanley Street, consecrated on September 28, 1980, and designed by Ramon Hovsepian of Worcester, Massachusetts. The construction manager was Gregory Der Abrahamian, PE. Poet Vahan Tekeyan writes, "The Armenian Church is the unyielding fortress / of our fathers' faith. They raised it / stone by stone out of the earth. / They lowered it dew fall by dew fall from the heavens. / They were buried in hushed stillness there."

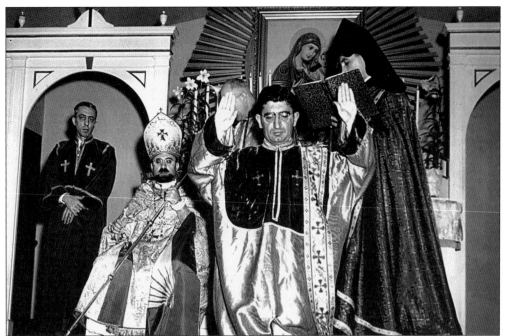

The ordination of Rev. Fr. Arnak Kasparian takes place in 1948 at the Armenian Church of the Holy Resurrection, while it still worshipped on Erwin Place. On the left is Archbishop Tiran Nersoian, and to the right is the presenter, Bishop Torkom Manoogian, who is now the patriarch of Jerusalem.

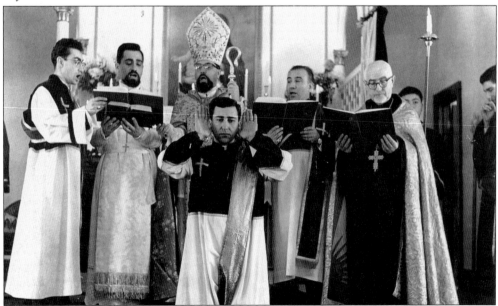

The ordination of Rev. Fr. Datev Kaloustian takes place at St. Stephen's Armenian Apostolic Church in the early 1960s. The symbolism of his hands signifies the denial of the earthly world and movement to the spiritual. Following the ordination, the priest enters 40 days of seclusion for mediation and prayer in the example of Jesus. The traditional Armenian Church traces its succession to the Apostles Thaddeus and Bartholomew, who went to Armenia.

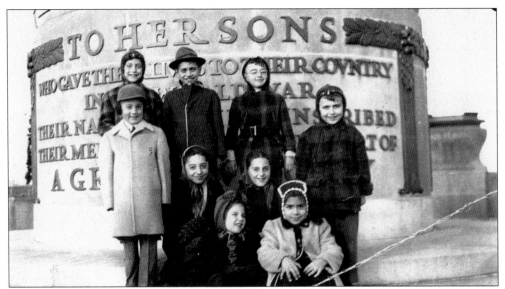

An Armenian Church of the Holy Resurrection Sunday school class visits Walnut Hill Park in 1944. Seen here are, from left to right, (first row) Ruth Hovsepian Swisher and Henrietta Boghosian Kallajian; (second row) Arthur Bagdasarian, Roxie Yessian Maljanian, Mary Yessian Der Abrahamian, and Harry Mazadoorian; (third row) Sam Hougas, Ara Der Bagdasarian, and Charles Mazadoorian.

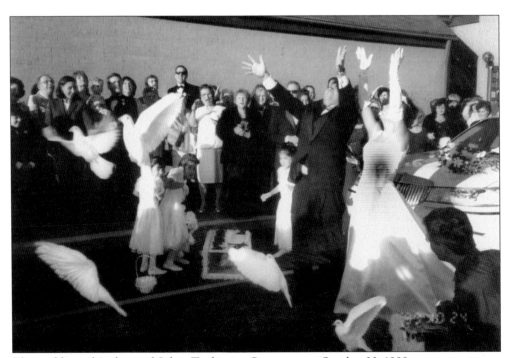

The wedding of Arthur and Sylvia Terdjanian Simonian on October 23, 1999, was a very joyous occasion. They are seen here releasing doves in front of the Armenian Church of the Holy Resurrection. This is an Armenian tradition, giving good wishes to the bride and groom.

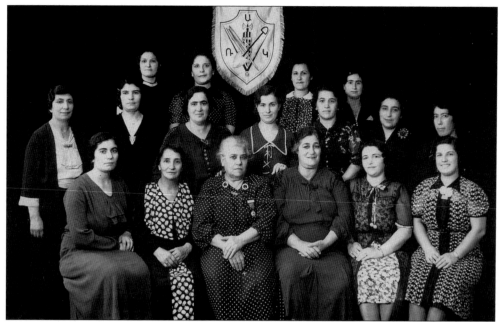

The local Women's Auxiliary of the Armenian Democratic Liberals came together for this formal photograph in the late 1930s. Seated are, from left to right, (first row) Siranoush Hovseipian, Sarah Hovhanessian, Dirhouhi Yessian, Yeghsa Simonian, Vartouhi Yessian, and Zevart Melikian; (second row) Mariam Mooradian, Mariam Sarkissian, Zarouhi Markarian, Elizabeth Yagoobian, Arshalous Manoogian, Arshalous Hoosigian, and Jouhar Der Margosian; (third row) Lucy Tatoolian, Ovsanna Hartunian, Maritza Bogosian Ohanessian, and Ovsanna Hovhanessian.

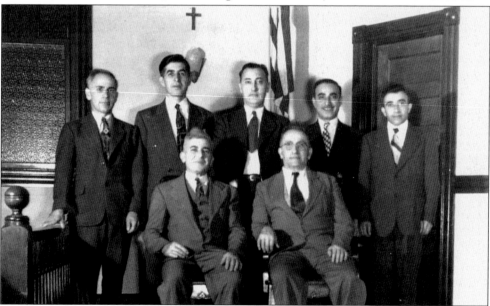

Seen here are members of the Armenian Church of the Holy Resurrection Parish Council in the 1940s. They are, from left to right, (first row) Sarkis Azarigian and Khevont Der Margosian; (second row) John Bogosian, Sarkis Grigorian, Eli Bagdasarian, Peter Badrigian, and Nighos Mazadoorian.

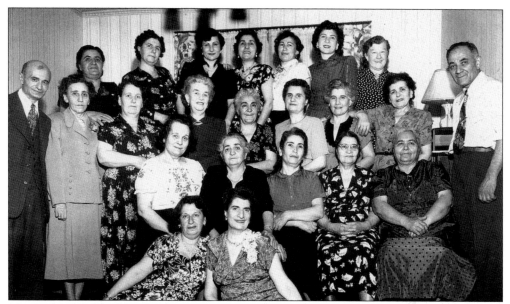

The Ladies Guild of St. Stephen's Armenian Apostolic Church gathered for a meeting at a member's home in the 1950s. Seen here are, from left to right, (first row) Victoria Armaghanian and Maré Atashian; (second row) Seran Davidian, Carnig Parparian, Baidzar Boghosian, Dirouhi Garabedian, and Takouhi Atashian; (third row) Hagop Atashian, Takouhi Boyajian, Vartanoush Atashian, Mary Serguis, Maro Papazian, Araxie Edgarian, Ruth Harotian, Arshalous Der Abrahamian, and Setrak Armaghanian; (fourth row) Vartouhi Avedisian Der Boghosian, unidentified, Varsenig Hartunian, Rose Jacobs, Yeghsapert Krikorian, Rose Karamian Parparian, and unidentified.

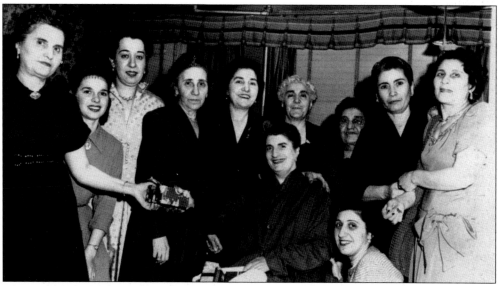

The Ladies Guild of St. Stephen's Armenian Apostolic Church is exchanging gifts at its Christmas party in 1950. Araxie Edgarian (left) is handing her gift to Maré Atashian. Seated is Rose Boyajian Bouley. Standing are, from left to right, unidentified, Beatrice Bagdasarian, Takouhi Boyajian, Rose Jacobs, Maro Papazian, Hripsime Kaprealian, Baidzar Boghosian, and Zarouhi Badrigian.

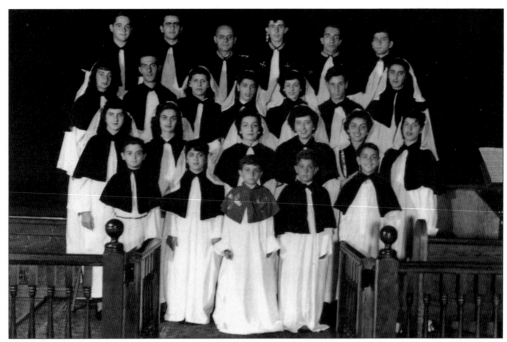

The church choir is very important to the liturgy of the Armenian Church. This is the choir group at the Armenian Church of the Holy Resurrection in the 1940s.

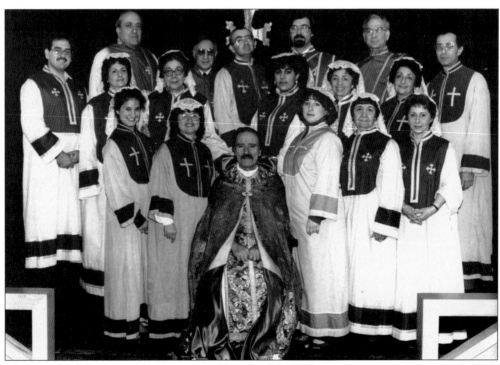

The choir and deacons at the Armenian Church of the Holy Resurrection in February 1987 are shown here with Rev. Fr. Michael Buttero, pastor of this church.

A couple of men attended the Ladies Guild meeting of St. Stephen's Armenian Apostolic Church in 1950 to drive their wives. Pictured are, from left to right, (first row) Setrak Armaghanian, Victoria Armaghanian, Mare Atashian, and Hagop Atashian; (second row) Nonig Parparian, Arshalous Der Abrahamian, Araxie Edgarian, Mary Serguis, Maro Papazian, Eva Krikorian, and Hripsime Kaprealian; (third row) Florence Parparian, Juanita Badrigian Alex, Rose Jacobs, Varsenig Hartunian, Yeghsapert Krikorian, Baidzar Boghosian, and Takoohi Boyajian.

The annual fall bazaar was held at St. Stephen's Armenian Apostolic Church as a fund-raising event. The committee consisted of, from left to right, Mae Sarkessian Demetriou, Zarouhi Garabedian, Marion Sagherian, and Araxie Edgarian.

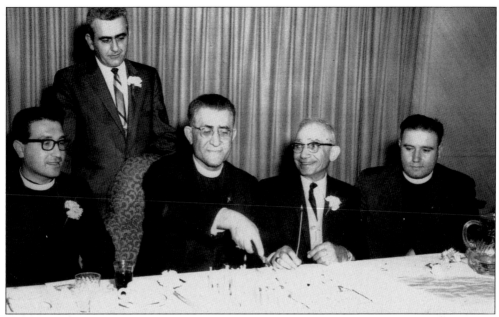

On May 9, 1966, the Armenian Church of the Holy Resurrection celebrated its 25th anniversary. Shown here is Most Reverend Archbishop Sion Manoogian, center, primate of the Armenian Church of America, who was the speaker. Standing is Hratch Azarigian, and seated to the right of the primate are Leon Azarigian, godfather of the church, and Rev. Fr. Michael Buttero, a local pastor.

The Endowment Committee of the Armenian Church of the Holy Resurrection meets in the summer of 1981. Seen are, from left to right, (first row) Manoog "Monty" Bagdigian, Edward Simonian, and Peter Bagdigian Sr.; (second row) Col. Victor Arzoomanian, Mary Abrahamian, and Charles T. Avedisian.

Members of the Hye Society are shown here with other youth from the First Congregational Church. Many Armenians had joined the Congregational church while they were still living in their homeland, because of the work of the missionaries who had gone there through the American Board of Missions.

The Hye Society held many outings. This one is at the Connecticut shore in 1948. Sunning themselves are Edward Magarian and Irene Sarkissian Yeager, Ph.D.

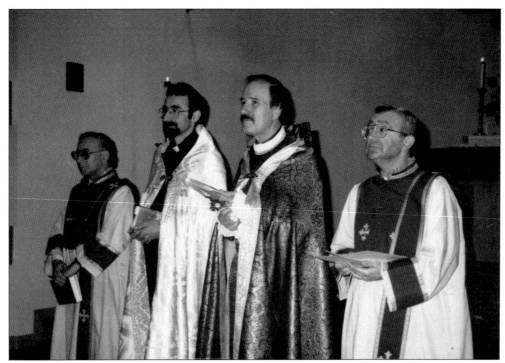

At the altar in 1989 in the Armenian Church of the Holy Resurrection are, from left to right, Deacon Paul Der Abrahamian, Rev. Fr. Yeprem Kelegian, Rev. Fr. Michael Buttero, and Deacon Charles Mazadoorian.

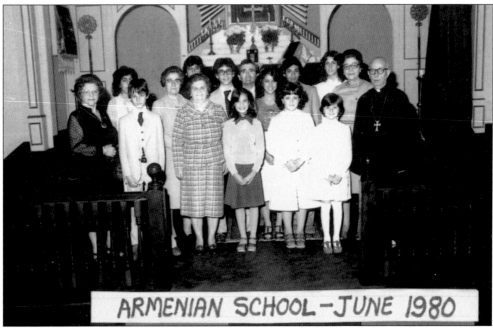

Armenian schools for the study of language and culture were held weekly at the churches. The students are with their teachers at the Armenian Church of the Holy Resurrection in June 1980. On the left is Rose Yessian, and to the right is the pastor, Fr. Vartan Der Assadourian.

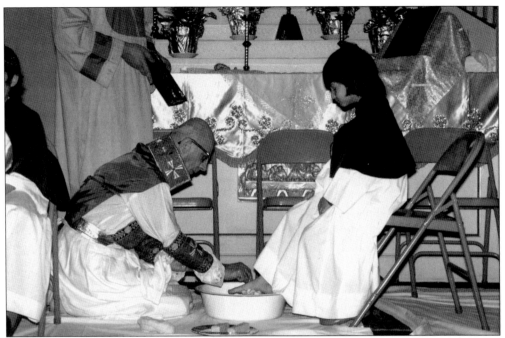

Holy Thursday is an important service in the Armenian Apostolic Church, beginning with washing of the feet as Jesus did for his Disciples. Fr. Vartan Der Assadourian is washing the feet of David Abrahamian in 1975. This is followed by the Tenebrae Service, when candles are extinguished one by one as the story of the crucifixion is read. The service ends with the church in total darkness as the priest sings a special hymn for that evening.

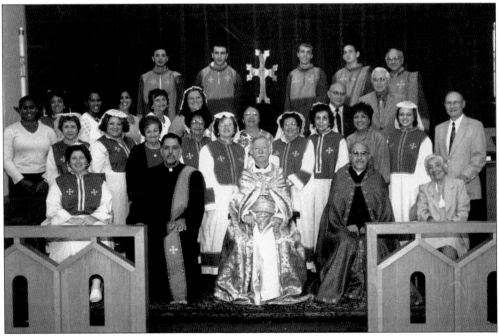

The present and past choir members of the Armenian Church of the Holy Resurrection gathered for this photograph in 2004.

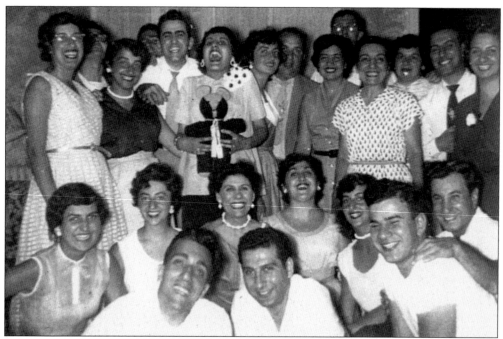

Young people used every opportunity to get together for a party. This is a farewell party for Harry Hougas, who entered the military in 1953.

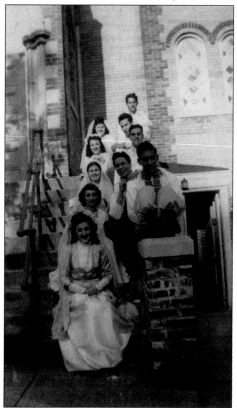

Armenian dance groups were formed and performed in costume at various programs throughout the year. Women in this group include, from front to back, Janet Sarkessian Der Aprahamian, Lila Jacobs Winters, Roxy Garabedian, Mae Sarkessian Demetriou, and Theresa Eknoian Khazarian.

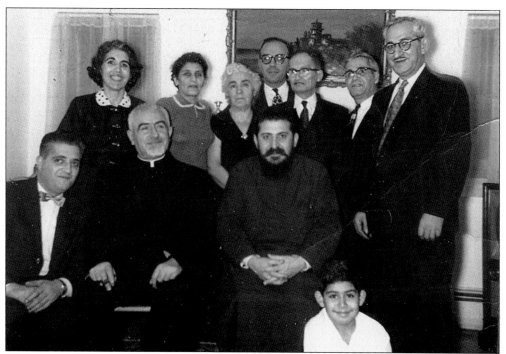

His Eminence Khoren Paroyan visited parishes in the United States in 1957. He was later elected catholicos of the Great House of Cilicia, Antelias, Lebanon, in May 1963. Members of the St. Stephen's Armenian Apostolic Church board of trustees in this photograph are, from left to right, (first row) Michael Eknoian, the Very Reverend Khachadour Giragosian, His Holiness Khoren I, and young Haig Shahverdian; (second row) Rose Shahverdian, Zarouhi Badrigian, Maro Papazian, Myron Sadoian, Yervant Papazian, Ashod Shahverdian, and Peter Badrigian.

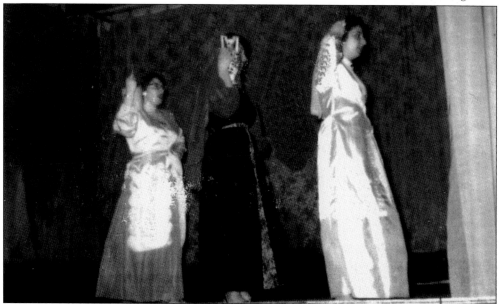

A production of the Armenian opera *Anush* was held in St. Stephen's church hall in 1955. From left to right are Helen Garabedian, Ph.D., Mae Sarkessian Demetriou, and Jennie Garabedian.

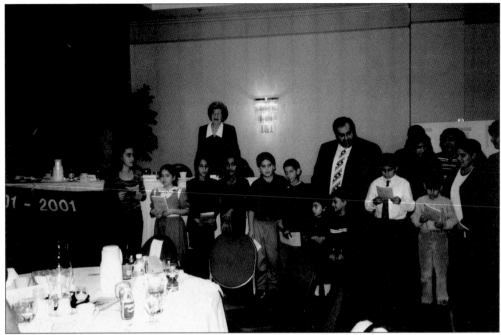

The Sunday school at St. Stephen's Armenian Apostolic Church is shown here in 2001 with choir director Shirley Kevorkian, standing in the rear, and teachers Richard Hamasian and Karen Hamasian Meyers.

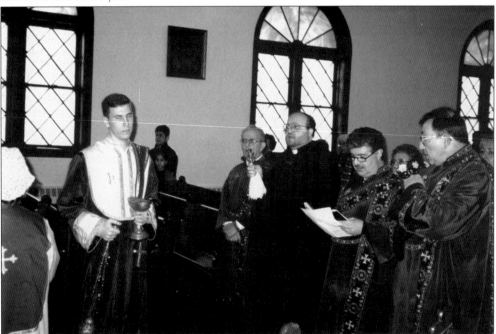

Deacon Krisotfer Der Bagdasarian, M.D., left, is participating in a special Lenten service at St. Stephen's Armenian Apostolic Church in the late 1990s. Standing are, from left to right, Deacon Bagdasarian, Deacon Aram Sampad Khachoyan, Rev. Fr. Krikoris Keshishian, Deacon Edward Varjabedian, and Deacon Sebouh Der Asadourian.

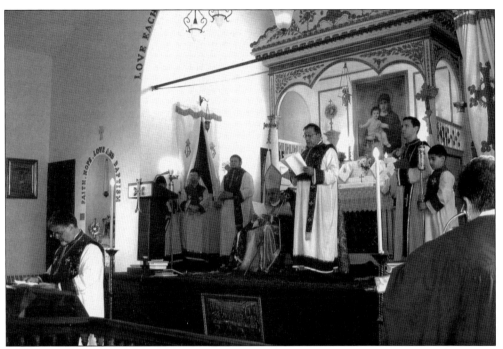

Sunday morning church service at St. Stephen's Armenian Apostolic Church on Tremont Street shows Deacon Edward Varjabedian reading announcements in the foreground and Deacon Sebouh Der Asadourian at the altar, with Deacon Kristofer Der Bagdasarian, M.D., to his left.

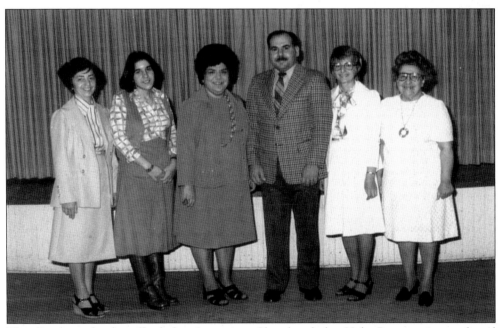

The Sunday school staff of the Armenian Church of the Holy Resurrection gathered for this photograph in 1977. Seen here are, from left to right, Roxie Maljanian, Cheryl Hoosigian Grasso, Henrietta Kallajian, Charles Takesian, Mary Abrahamian, and Arshalous Yagoobian Hoosigian.

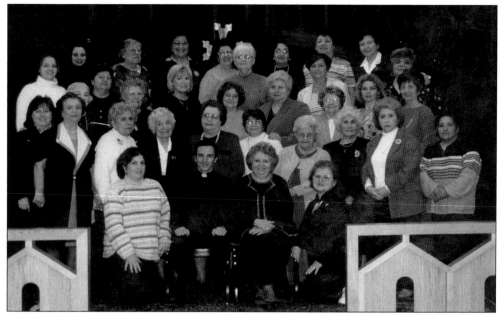

The Women's Guild of the Armenian Church of the Holy Resurrection gathered for this photograph in 2001. Seated in front is the deacon in charge, Hamlet Mehrabian.

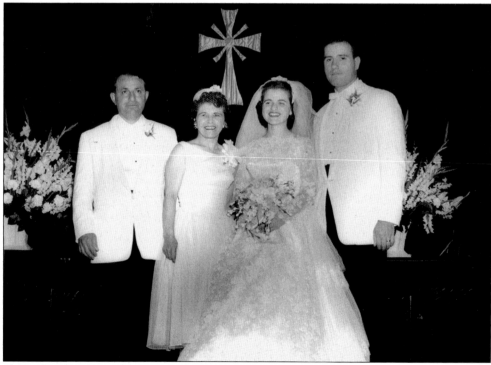

Shown here is the wedding on May 17, 1958, of Patricia Bagdigian to a local member of the community who later became Rev. Fr. Michael Buttero, pastor of the Armenian Church of the Holy Resurrection. At the happy occasion, the bride and groom are standing with Patricia's parents, Peter and Margaret Bagdigian.

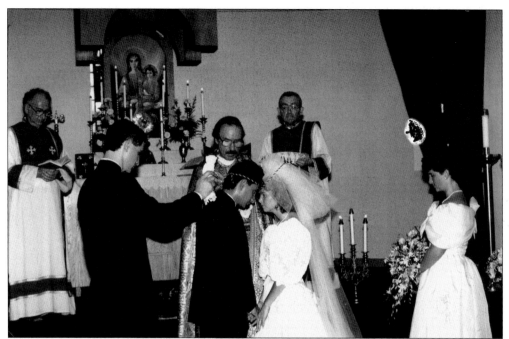

Weddings in the Armenian community are times of great joy with a great deal of significance in the ceremony. On June 4, 1989, the wedding of John and Jeanne Carlisle Abrahamian took place at the Armenian Church of the Holy Resurrection. The symbol of touching foreheads in the ceremony depicts becoming one in mind. The "godfather" (best man) is holding the cross over the heads of the bride and groom, becoming one in Christ.

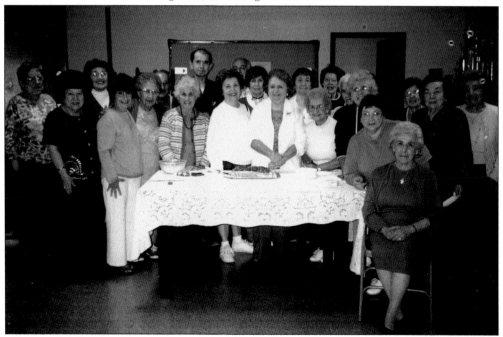

The New Britain Armenian Seniors Group meets every Wednesday at the Armenian Church of the Holy Resurrection. This photograph was taken in the early 1990s.

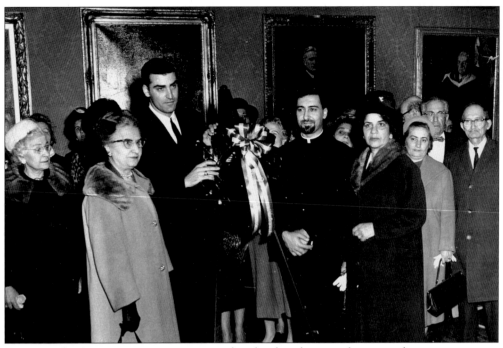

Every year the Armenian community remembers lost loved ones with a genocide commemoration on April 24. This group is gathered at the Hartford state capitol for this ceremony in the late 1960s.

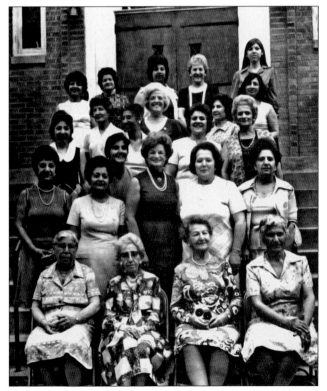

The Ladies Guild of St. Stephen's Armenian Apostolic Church gathered in front of the church for this photograph in 1975. Seen here are, from left to right, (first row) Takouhi Sarkissian, Takouhi Boyajian, Mare Kevorkian, and Zarouhi Garabedian; (second row) Mary Kaprealian, Seranoush Antreassian, Roxy Garabedian, Shirley Kevorkian, Marion Sagherian, and Rose Boyajian Bouley; (third row) Adrienne Sarkissian Brown, Hasmig Papazian, unidentified, Elizabeth Esoian, Lucy Atashian Horenian, Yeretzgin Andekian, and Helen Atashian Sahady; (fourth row) Elizabeth Eknoian Wojculewicz, Armenouhi Hanisian, unidentified, Peggy Papazian Wolf, and Rita Soovajian.

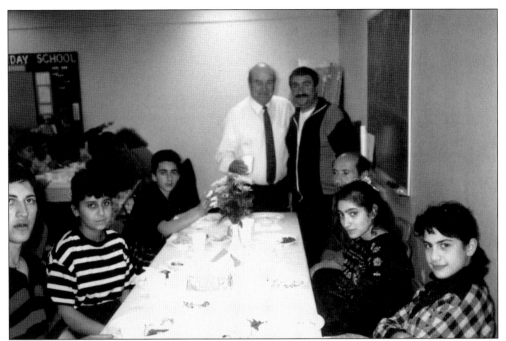

A devastating earthquake hit Armenia in 1991, shortly after the fall of the Soviet Union. The Armenian communities in the United States mobilized to do all they could to come to the victims' aid. A group of teenagers was brought to this country for a short time. New Britain families hosted them, and shown here is a small part of the group at its farewell dinner.

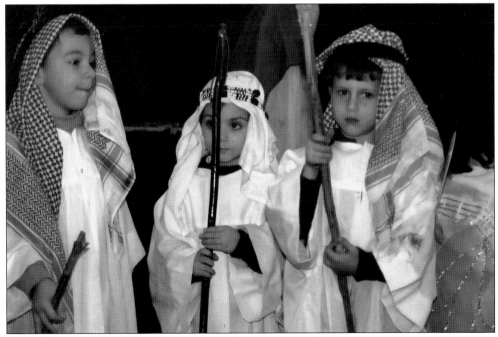

The Christmas pageant at the Armenian Church of the Holy Resurrection is an important event for both the children and their parents. The three shepherds in this photograph taken in 2004 are, from left to right, Nicholas Kallajian, Justin Picard, and Samuel Roy.

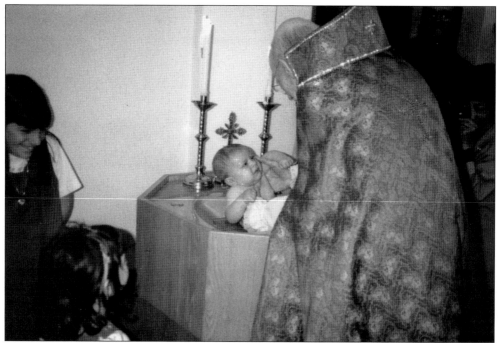

Christening and confirmation in the Armenian Church are done at the same time for infants by chrismation (holy oil). On April 18, 1998, at the Armenian Church of the Holy Resurrection, Samuel Roy is being baptized by the Very Reverend Mesrob Semerdjian.

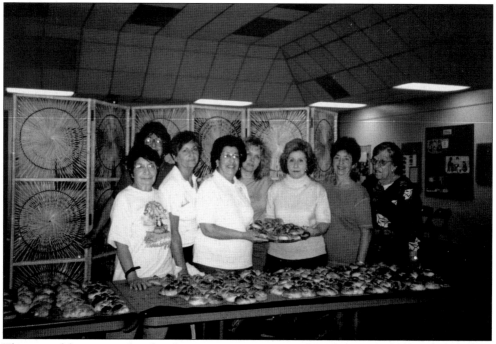

The annual bazaars at the churches are a major source of fund-raising. *Choereg* is Armenian sweet bread served with coffee and tea. The Women's Guild of the Armenian Church of the Holy Resurrection gathered for a "choereg workshop" to prepare for the annual bazaar in 2001.

The church hall is always a place for socializing and visiting friends on Sunday morning after services. Rev. Fr. Krikoris Keshishian, right, pastor of St. Stephen's Armenian Apostolic Church, is visiting with Avak Avakian.

Stella Rustigian is visiting with her son-in-law Vahe Oshagan, Ph.D., and Deacon Aram Semipad Khachoyan (left) on a Sunday morning in the 1990s in St. Stephen's church hall.

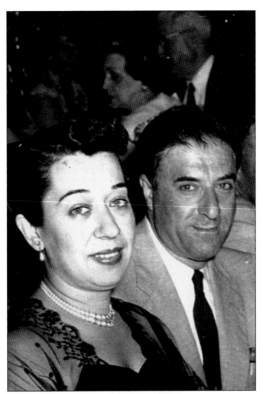

Steve Bagdasarian served on the board of trustees of St. Stephen's Armenian Apostolic Church for many years and owned a plumbing company in New Britain. He is seen here with his wife, Beatrice. Steve and his sons David and Reuben were very helpful in helping Armenian families relocate to New Britain in the 1950s from other parts of the world.

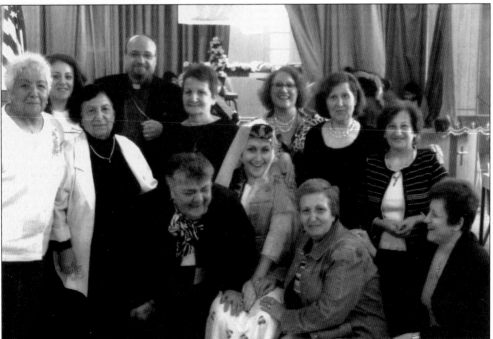

Many folk traditions are connected to religious holidays in the Armenian Church activities. This group of women came together for Ascension Day in the old tradition of *vijag*. Young girls believed their wishes would come true as someone told their fortune.

94

Five

ARMENIANS IN SPORTS AND THE MILITARY

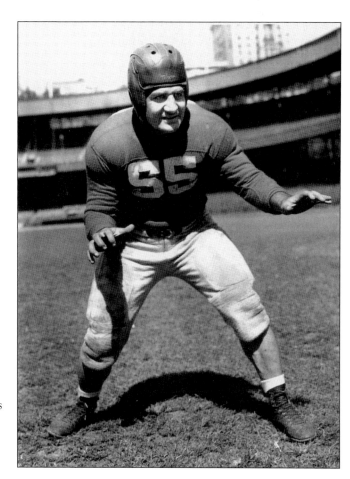

Charles T. Avedisian played with the New York Giants from 1942 to 1944. When he came to New Britain, he served as athletic director for the New Britain school system. He made a major contribution to the Armenian community by researching New Britain in its early days. This information is part of the history room at the New Britain Public Library.

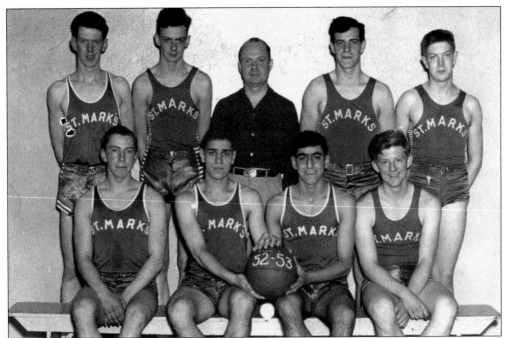

Ara Der Bagdasarian, M.D., seated second from left, is shown playing basketball with St. Mark's Episcopal Church in the YMCA basketball league. At times, there were not enough priests to keep the Armenian Church active. During these periods members attended other churches in the community.

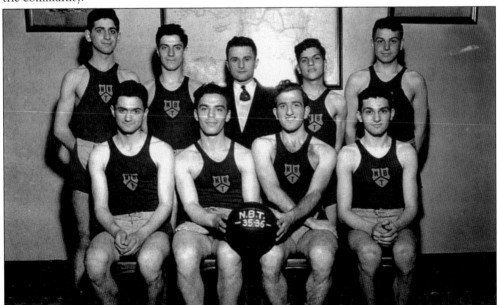

This is the New Britain Armenian Youth Federation basketball team, known as the Triangles, in the season 1935–1936. Seen here are, from left to right, (first row) Edward Davidian, Myron Sadoian, William Derderian, and Steve Kevorkian; (second row) Aram "Otto" Bayram, Arthur Edgarian, Andrew Bagdasarian, Edward Jacobs, and Arthur Kevorkian. They played other Armenian teams in various Northeast cities.

Arthur Kevorkian was captain of the Teacher's College of Connecticut (now Central Connecticut State University) football team following World War II, September 1946. The mascot is Jimmy Dooman's son. Kevorkian has been honored as a member of the New Britain Sports Hall of Fame.

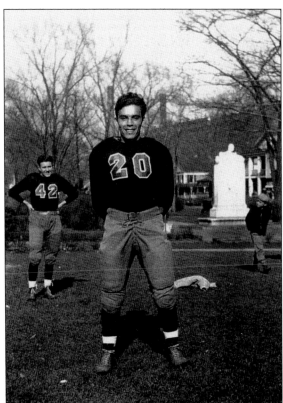

Myron Sadoian, New Britain High School 1936, played guard with Arthur Kevorkian and Edward Davidian on the championship football team that went to Miami and won the national championship in the Orange Bowl of November 1936. Appropriately he is standing in front of the monument facing the old New Britain High School, which was dedicated to Elihu Burritt, 1810–1879, "the learned Blacksmith," a son of New Britain. The inscription reads, "Peace and Universal Brotherhood."

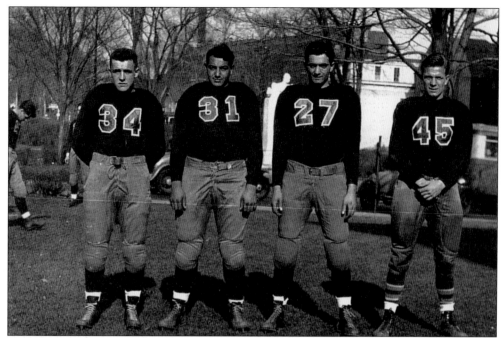

Members of the New Britain High School national championship team who played in the 1936 Miami Orange Bowl are seen here. Arthur Kevorkian, No. 31, and Edward Davidian, No. 27, are standing here in their uniforms.

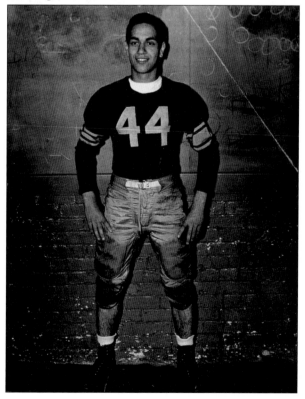

Ara Der Bagdasarian, M.D., a member of the New Britain Sports Hall of Fame, is in his New Britain High School football uniform. He and his brother John won the Conley Award at New Britain High School in the 1950s. This is an award given for the most valuable football player on the team. Ara went on to graduate from Yale University as a scholar of the first rank, Stanford University Medical School, and the Dartmouth College surgical program. He became chief of surgery at Bristol Hospital.

John Baldasarian, No. 43 in the front row, was inducted posthumously into the New Britain Sports Hall of Fame. After graduating from New Britain High School, he went on to Harvard University, and then to the University of Connecticut Law School, where he was chairman of the law review and salutatorian of his class.

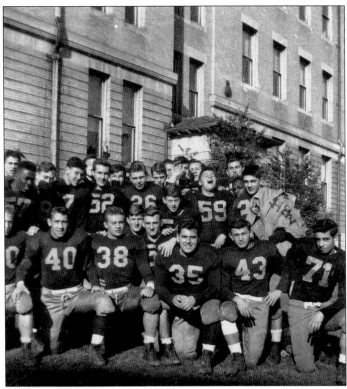

An earlier generation had fought battles and won awards not on the sports field. John Hovhannes Der Abrahamian had joined the U.S. Army during World War I.

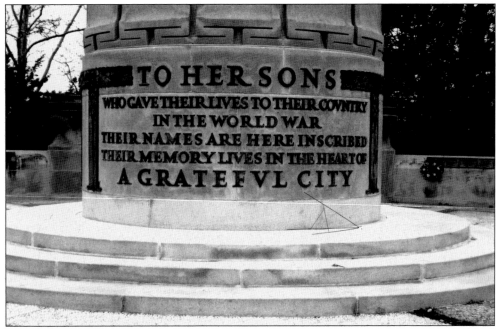

TO HER SONS
WHO GAVE THEIR LIVES TO THEIR COVNTRY
IN THE WORLD WAR
THEIR NAMES ARE HERE INSCRIBED
THEIR MEMORY LIVES IN THE HEART OF
A GRATEFVL CITY

Walnut Hill Park has always been very important to the Armenian community. It was always a place to take visiting relatives. Note the inscription at the base of the monument. Each time Armenians would visit the memorial at Walnut Hill Park, they would point with pride to the plaque in the name of Hoohanes Hanisian, who died in World War I on November 17, 1917.

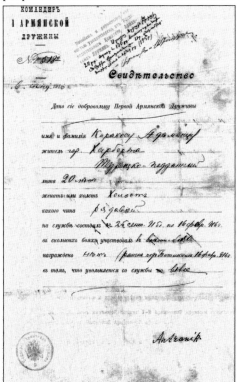

While a group of Armenians was fighting under Gen. Edmund Allenby and the Allied forces in the south of Turkey, another group of volunteers was fighting under the Armenian general Antranik Ozanian on the eastern front. It managed to secure a small part of historic Armenia at Sardarabad to become an independent free nation in 1918. This commendation from Gen. Antranik Ozanian was given to George Atamian, who fought and was wounded in this army.

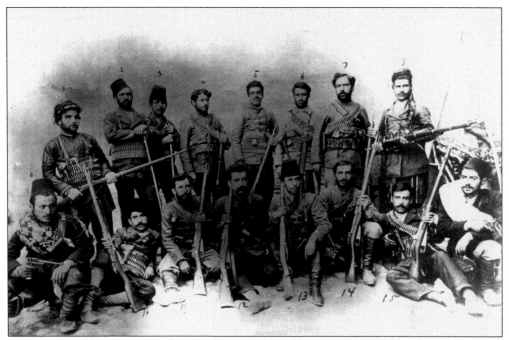

This is a group of volunteers that was fighting under Gen. Antranik Ozanian on the eastern front for the freedom of Armenia in 1918. After learning of the genocide of the Armenians in Turkey, many of these men, who were living in the United States and Europe, went to help their loved ones.

Nishan Kerekian joined the group of American volunteers that was part of the Eastern Legion of the French Foreign Legion during World War I. The legionnaires marched through the desert to the Palestine front to join the Allied forces, commanded by British general Edmund Allenby. A great deal of this history is detailed in a personal biography by Ohannes John Garabedian, who also served in this army.

Garabed Hovsepian is kneeling front left while he served as one of the American volunteers in the French army to serve the Armenian people in the Middle East during World War I.

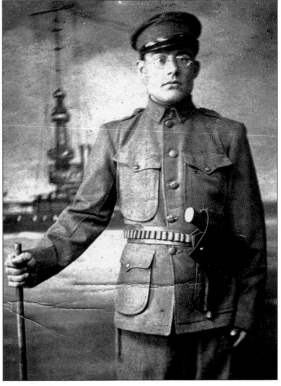

Avedis Boyajian, father of Angel Boyajian Yirigian, served as a soldier in the Eastern Legion (Legion d'Orient). Under agreement with England and France, this legion was formed in 1916 under French auspices to fight against Turkey. Over 1,200 volunteers joined this army from the United States. Armenians were promised autonomy over the region of Cilicia in Turkey, which never happened. He was born on December 15, 1892, in Kharpert, Turkey, and died at the age of 53 in the United States.

Mesak Baronian was one of the American volunteers who served under Gen. Edmund Allenby in World War I, fighting against the Ottoman Empire. The only survivors of his family were his mother, Almas Baronian, and his daughter Margaret Baronian Bagdigian. Margaret's uncle Setrak was living in New Britain and sent for his mother and niece when he found they had survived.

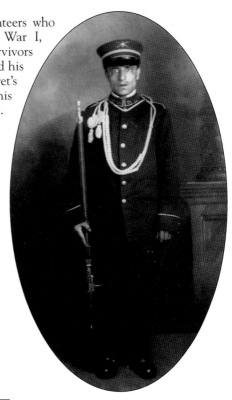

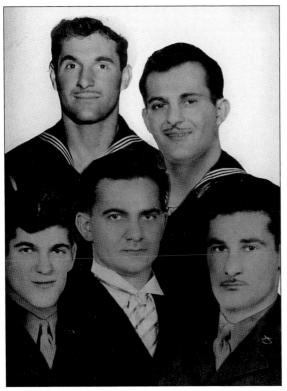

A generation later, four of the five Marzbanian brothers were in the service during World War II. Seen here are, from left to right, (first row) Haig in the army; Hagop "Jake," civilian, and Barouyr, army; (second row) Marzbed "Mike," navy, and Vahe, navy, who died in the Pacific theater while serving on the USS *Bunker Hill*.

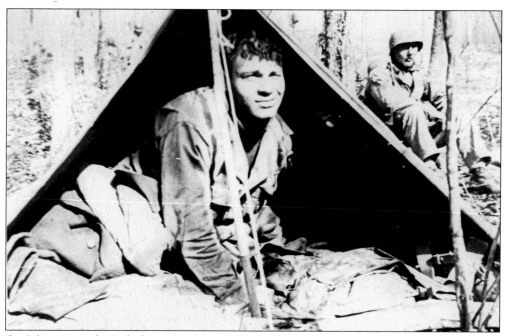

On July 4, 1944, the Tufenkjian family received the dreaded telegram about son Arthur. He had died in Normandy at the age of 22 in the war.

The *New Britain Herald* of December 18, 1944, reported the death of Harry Harutunian while rescuing a buddy crossing a river in Italy. He was the son of Nishan and Maritza Harutunian of West Main Street. Private Harutunian had previously received the Purple Heart for his bravery.

Matthew Barsoian, the brother of Agnes Barsoian Karanian of New Britain, was in the service and killed in the Normandy invasion during World War II at the age of 34, leaving his wife a widow.

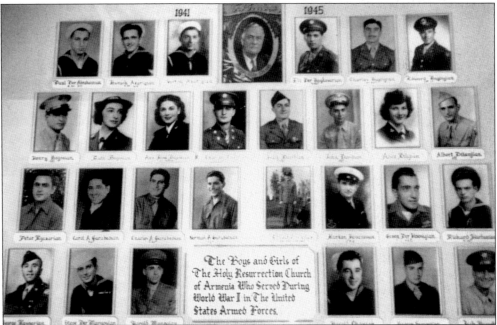

A plaque hangs in the Armenian Church of the Holy Resurrection honoring young men and women who served during World War II.

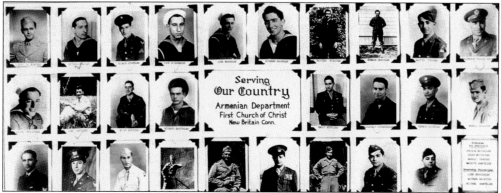

Young persons from the Armenian congregation at the First Church of Christ in New Britain were in the service of the United States during World War II.

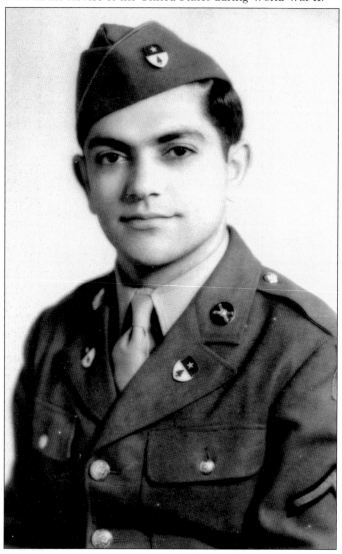

Arthur Yeterian served in the European theater during World War II in 1942.

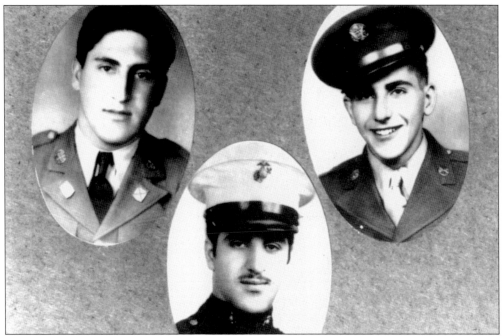

All four of the Alex brothers served in World War II. Shown here are three brothers. Charles (left) served in the army, Carroll Alex (center) served in the Marine Corps, and Norman served in the army. Armand was in the army but is absent from this photograph.

Armand Alex served in World War II in the Pacific and Japan.

Stephen Der Margosian was in the U.S. Navy during World War II. He served as electrician's mate aboard the battleship USS *Iowa*.

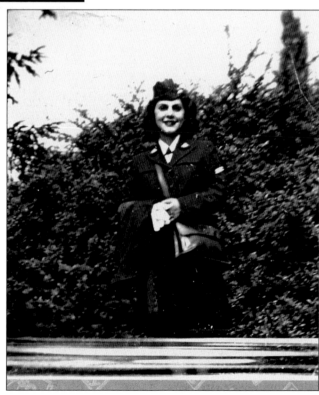

Ann Bogosian Sadoian served in the WAVES during World War II.

Seranoush Davidian is together with her son Edward Davidian, who is home on leave in the 1940s.

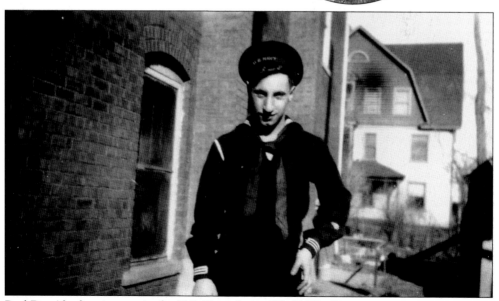

Paul Der Abrahamian was in the U.S. Navy during World War II.

John Margosian, right, went out of his way to see Henry Karanian in Cheng-Chou while they were both in China during World War II. The Margosian family had also come to the United States from the city of Van, which automatically made each family call the other cousin. The rest of the community called them the "Vanetzis." The Margosians later moved to California.

Three members of the Karanian family are here in their service uniforms during World War II. From left to right are Henry, Charles, and Richard.

Henry Karanian is talking with his young Chinese friend Chen during World War II while he was serving in Shanghai.

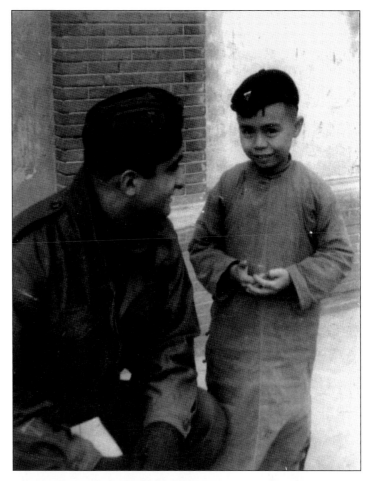

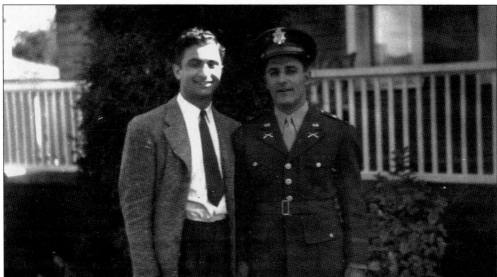

Jacob Haroian, right, is shown here with his friend Henry. This is another pair of "Vanetzis."

Aram Otto Bayram was a captain in the U.S. Air Force during World War II and led the raid to Rome.

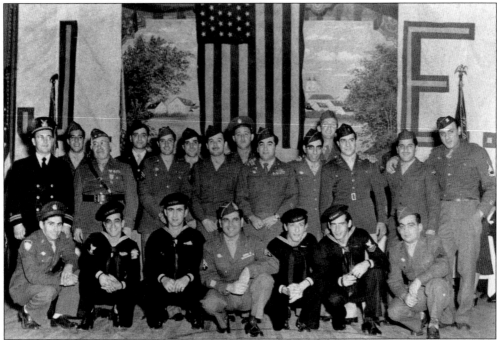

A few of the Armenians and Assyrians who served during World War II are in this photograph together. Standing fourth from the right is Otto Bayram, and in the first row, second from the right, is Carroll Alex. Also among those pictured is Dick Vardanian.

Harry Badrigian served in the U.S. Navy from June 28, 1946, to April 28, 1948. He served on the USS *Randolph* CV15, USS *Kersage* CV33, and USS *Saipan* CV33.

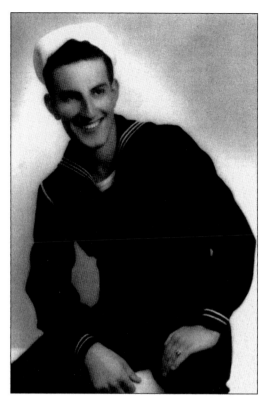

Aram Atashian served in the U.S. Navy during World War II and is pictured here with his sister Lucy Atashian Horenian.

Kirk Atashian is home from the U.S. Navy during World War II, with his mother, Takoohi, his sister Lucy, and his father, Avedis, who was one of the founders of St. Stephen's Armenian Apostolic Church.

The most important Olympic games of the Armenian Youth Federation were held in September 1946 just after the war. Chapters from all over the United States participated in this major event. The war was over, and the boys had come home; it was a time of great rejoicing. Henry Karanian officiated at the track-and-field events. As a side note, many romances were initiated at the New Britain Olympics.

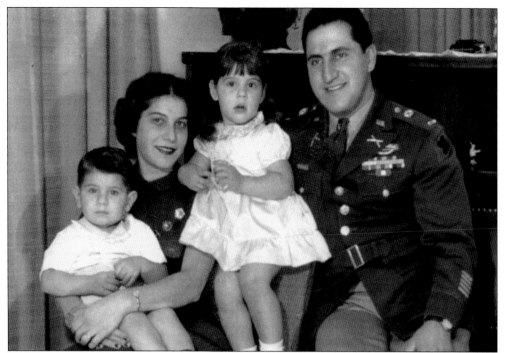

Col. Charles Garabedian Alex made the army his career. He is here in the 1950s, while stationed in Germany, with wife Juanita Badrigian Alex, his son Dennis, and daughter Patricia.

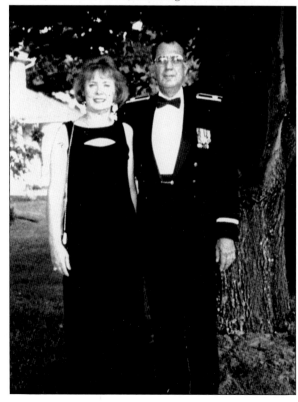

Lt. Col. George Rustigian retired from his U.S. Air Force career in 1989 and returned to the New Britain community to take an active role in St. Stephen's Armenian Apostolic Church. He is with his wife, Barbara, at a formal military affair in 1998.

Ara Der Bagdasarian, M.D., is at the right, while in army service in Germany during the Vietnam War.

Lt. Col. Douglas G. Der Bagdasarian, graduate of United States Army Command and General Staff College and the National Defense University's Joint Forces Staff College, served in every major conflict in the 1980s and 1990s. During Desert Shield and Desert Storm, he earned the Bronze Star Medal. He served in the Balkans crisis in Macedonia, Bosnia, and Kosovo. He was wounded by an improvised explosive device and earned the Purple Heart and Combat Action Badge while with the Iraq Assistance Group. He is presently with the Pacific Command and Operation Enduring Freedom, in the Philippines.

Six

THE FUTURE IS BRIGHT

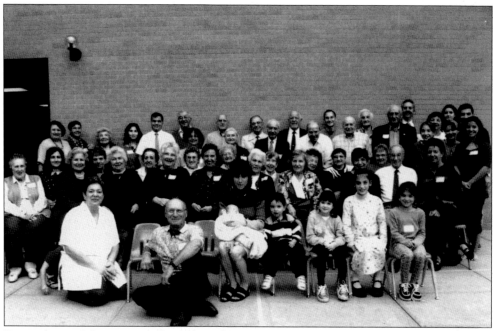

Descendants of the survivors from the village of Garmery in the province of Kharpert came together in 1999 at the Armenian Church of the Holy Resurrection. In the early days when picnics were held for this group, there would be as many as 300 persons. People who had lived in neighboring villages would also attend this gathering. Names of most Armenian villages in Turkey have been changed. This village is now called Yedeguz.

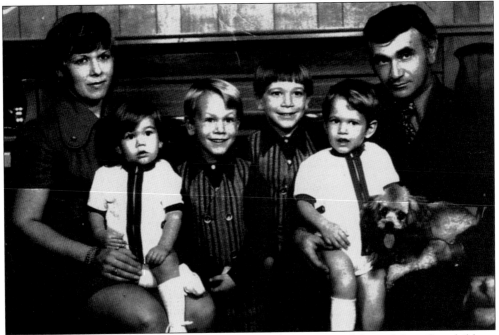

Attorney John Der Bagdasarian is here with his wife, Louise, and four of their five children. Seen here are, from left to right, Louise, Timothy, John, Douglas, Ara, and John. Their daughter, Tamara, was not yet born when this photograph was taken. He practiced law in the city of New Britain and served for a time as corporation counsel for the city.

Varujan Boghosian and Hasmig Boghosian Sillano were born to Mesrop and Baidzar Salyandjian Boghosian in New Britain. Mesrop wrote to the orphanage for a bride, and Baidzar was sent. Varujan has gained fame as one of the foremost contemporary artists in this country. Hasmig graduated from Central Connecticut State College, married Arthur Sillano, and later moved to San Diego.

The Honorable Evelyn Mukjian-Daly became judge of probate in November 2007. Three generations are in this photograph: from left to right, Evelyn Mukjian-Daly, her son John Mukjian-Daly, and her mother, Evelyn Talanian Mukjian.

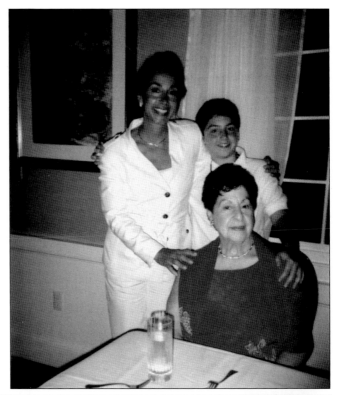

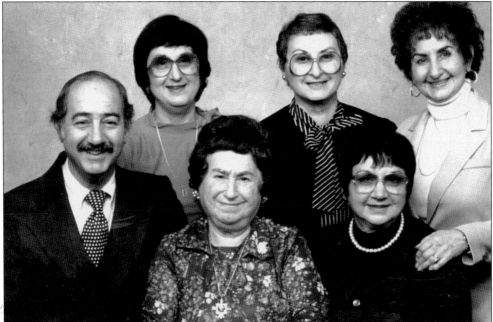

The Hovhanessian family is seen here. The family lived first on Tremont Street and then moved to Carlton Street. From left to right are (first row) son Bagdasar "Baggy" Hovhanessian, mother Ovsanna, and daughter Eleanor Hovhanessian Conochalla; (second row) daughters Sarah Hovhanessian Sansone, Annie Hovhanessian Granno, and Elizabeth Hovhanessian Kalagian.

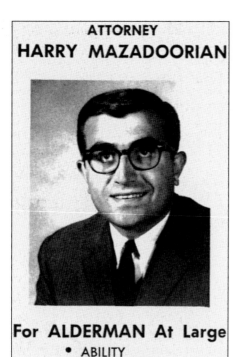

Armenians from New Britain have become very involved in local politics. Harry Mazadoorian served as corporation counsel for the city after he served as alderman. His cousin John Der Bagdasarian also served in that capacity, and Andrew Aharonian served as city attorney. Harry Badrigian ran for mayor, twice. John C. Geragosian is presently state representative from the 25th District, which includes New Britain.

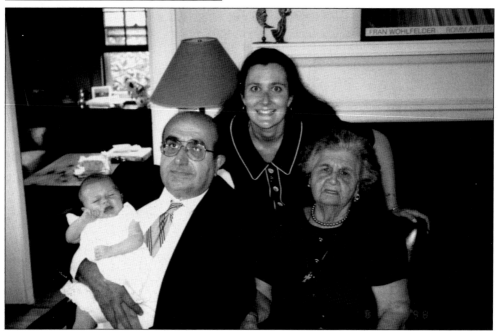

Four generations of the Mazadoorian family gathered for this photograph. Infant Margaret Keithline is shown with her grandfather Harry Mazadoorian, great-grandmother Elizabeth Yegsa Mazadoorian, and, standing, her mother, Beth Mazadoorian Keithline.

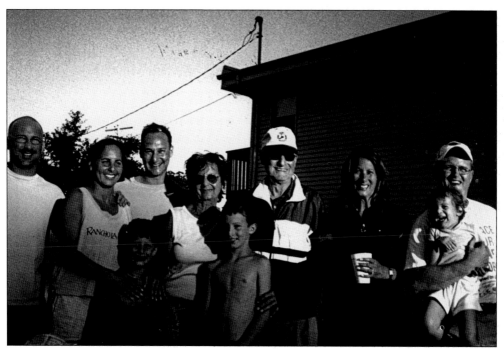

The children and grandchildren of the Abrahamian family gathered for the 50th wedding anniversary of their parents, Gregory Der Abrahamian and Mary Yessian Abrahamian, on July 9, 2005.

Lee Abrahamian is on the right with her cousin Debra Maljanian Kerr. Abrahamian recently left her position as executive producer at MSNBC in New York City to assume her new duties as communications director for the Metropolitan Opera Company. Kerr just retired from her teaching position at the E. O. Smith School in Storrs.

Arthur and Lucy Yessian Simonian are gathered at the Shuttle Meadow Club with their children and grandchildren to celebrate the 50th birthday of their son Craig and their daughter-in-law Brenda in 2006.

Every July 4, the Yessian sisters gather with their children at the beach as they always did when they were growing up. In this photograph taken on July 4, 2004, the Abrahamian, Maljanian, and Simonian families are together with relatives from California at the summer home of Lee Abrahamian at the Connecticut shore.

The family of Arthur and Mary Hartunian Yeterian is gathered for a Christmas celebration.

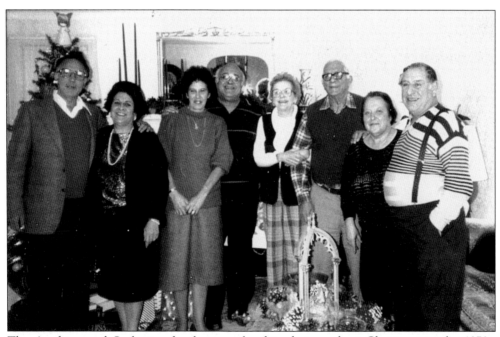

The Atashian and Sagherian family poses for this photograph at Christmas in the 1970s. Seen here are, from left to right, Ara Horenian, Lucy Atashian Horenian, June Atamian Atashian, Aram Atashian, Margaret and Kirkor Atashian, Marion Atashian Sagherian, and Paul Sagherian.

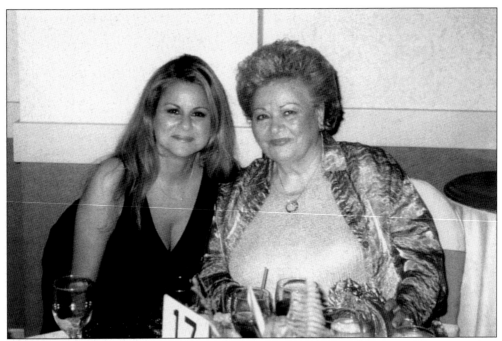

Christine Magarian Ucar, left, is here with her mother, Rosine Magarian. Ucar moved to Hollywood and is currently the director and editor of the television show *General Hospital*.

Callie Thorne, left, is with her grandmother Beatrice Davidian Oshana. Thorne is an actress in New York City and just recently worked with Eric Bogosian in an off-Broadway production *The Last Days of Judas Escariot*. She has also appeared in the television shows *Law and Order*, *Homicide*, and *ER* and is currently in *Rescue Me*.

Ara Der Bagdasarian, M.D., is with his son Rainer W. Bagdasarian, M.D., in the operating room at Bristol Hospital where both work as surgeons.

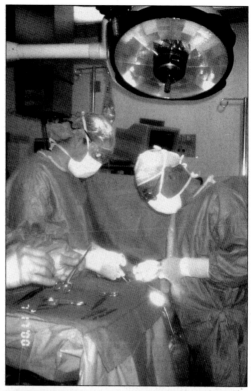

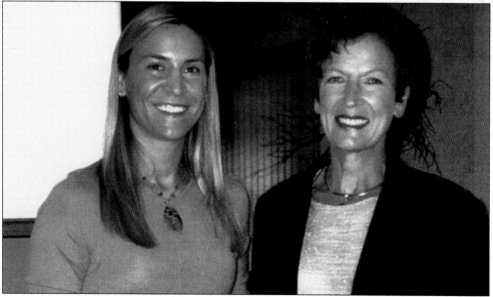

Attorney Sabrina Bagdasarian is with her mother, Renate, in this photograph. Sabrina received a bachelor of science degree from Georgetown University, a juris doctor degree from New York Law School, and a master of arts degree from George Washington University's Elliott School of International Affairs. As this New Britain community gets smaller, others have the benefit of its members. Sabrina passed the bar examinations in Connecticut, New York, New Jersey, and Washington, D.C.

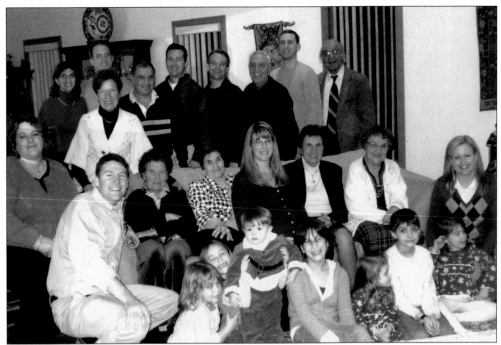

"There were only two of us, where did all these people come from?" From one and two survivors, families are multiplying. The Bagdasarian and Garabedian family gathered for a happy Christmas celebration in 2007.

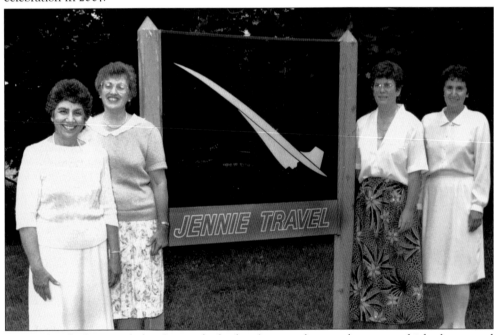

Jennie Garabedian used the Concorde for her logo at the travel agency, which she started in 1977 after she left the YMCA as a professional director of the adult program and world service departments. This was taken in front of that sign, and seen are, from left to right, Mary Boornazian, Helen Garabedian, Ph.D., Carol Prendergast, and Jennie.

126

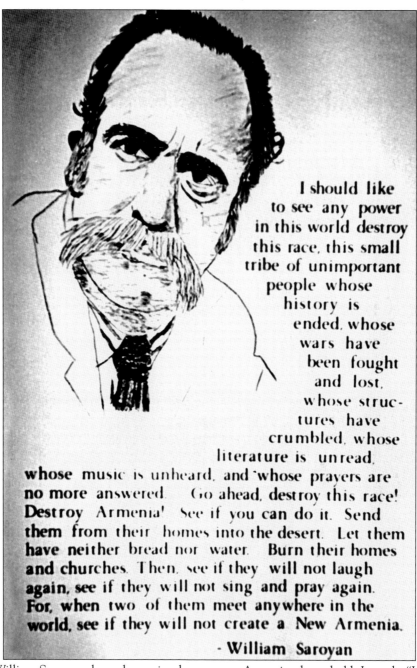

I should like
to see any power
in this world destroy
this race, this small
tribe of unimportant
people whose
history is
ended, whose
wars have
been fought
and lost,
whose struc-
tures have
crumbled, whose
literature is unread,
whose music is unheard, and whose prayers are
no more answered. Go ahead, destroy this race!
Destroy Armenia! See if you can do it. Send
them from their homes into the desert. Let them
have neither bread nor water. Burn their homes
and churches. Then, see if they will not laugh
again, see if they will not sing and pray again.
For, when two of them meet anywhere in the
world, see if they will not create a New Armenia.

- William Saroyan

This William Saroyan plaque hangs in almost every Armenian household. It reads, "I should like to see any power in this world destroy this race, this small tribe of unimportant people whose history is ended, whose wars have been fought and lost, whose structures have crumbled, whose literature is unread, whose music is unheard, and whose prayers are no more answered. Go ahead, destroy is race! Destroy Armenia! See if you can do it. Send them from their homes into the desert. Let them have neither bread nor water. Burn their homes and churches. Then, see if they will not laugh again, see if they will not sing and pray again. For, when two of them meet anywhere in the world, see if they will not create a New Armenia."

ACROSS AMERICA, PEOPLE ARE DISCOVERING SOMETHING WONDERFUL. *THEIR HERITAGE.*

Arcadia Publishing is the leading local history publisher in the United States. With more than 3,000 titles in print and hundreds of new titles released every year, Arcadia has extensive specialized experience chronicling the history of communities and celebrating America's hidden stories, bringing to life the people, places, and events from the past. To discover the history of other communities across the nation, please visit:

www.arcadiapublishing.com

Customized search tools allow you to find regional history books about the town where you grew up, the cities where your friends and family live, the town where your parents met, or even that retirement spot you've been dreaming about.